SKETCHBOOK

MILIND MULICK

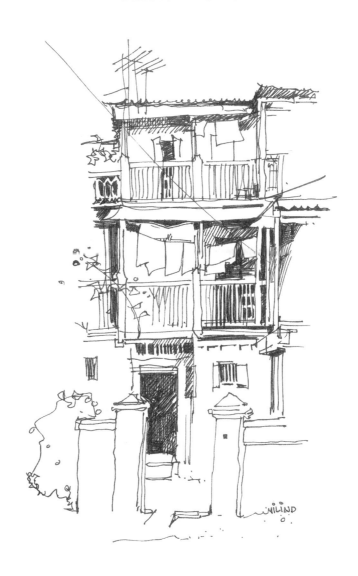

JYOTSNA PRAKASHAN

Publisher :
Milind L. Paranjape, Jyotsna Prakashan
'Dhavalgiri', 430-31 Shaniwar Peth, Pune 411 030

Mumbai Office :
Mohan Building, 162-B, J. S. S. Road
Girgaum, Mumbai 400 004

First Edition: January 2004
Reprint: 2004, 2004, 2005, 2007

Layout: Ravindra Avachat

Printer : Printmann, Adhyaru Ind. Estate
Lower Parel, Mumbai 400 013

ISBN : 81-7925-103-9

jyotsnaprakashan@vsnl.com

Price Rs. 130/-

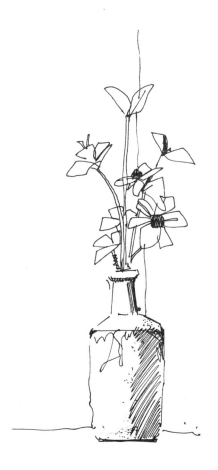

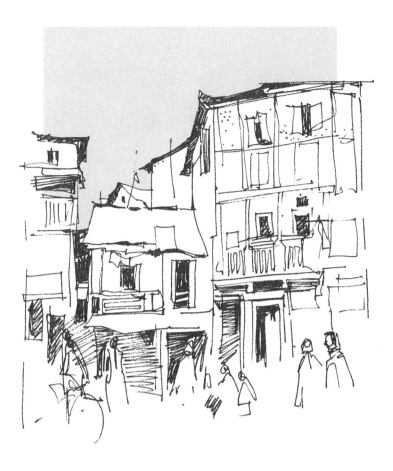

Sketching and drawing form a major part of my study of painting. I like my sketches more than my paintings. We are aware of the importance of sketching or drawing. As John Sloan, the famous American painter, maintains, "Painting is a drawing with additional means of colours." Handling colours, composition, structure, brushwork are extension of our own drawing.

Sketching gives practice to one's hands and eyes. While improving the senses of perspective and proportion, one can also observe compositions better. Above all, sketching develops one's own point of view. In any painting, the viewpoint of the painter is as important as (or perhaps even more than) the technical skills. A painter stands out from another because of his different point of view. The independent style of a painter evolves out of his point of view; it is not the result of a different manner of colouring or new experiments in techniques.

A painter is different from a common man not only because he can paint but also due to his attitude. To develop this attitude, one need not spend long hours practising in a studio. What is expected is to watch the world independently.

One's own style comes of one's perception of what should be shown in the picture; what should be emphasized, and to what extent; what should be concealed and what should be avoided. The perception will obviously differ as per one's nature.

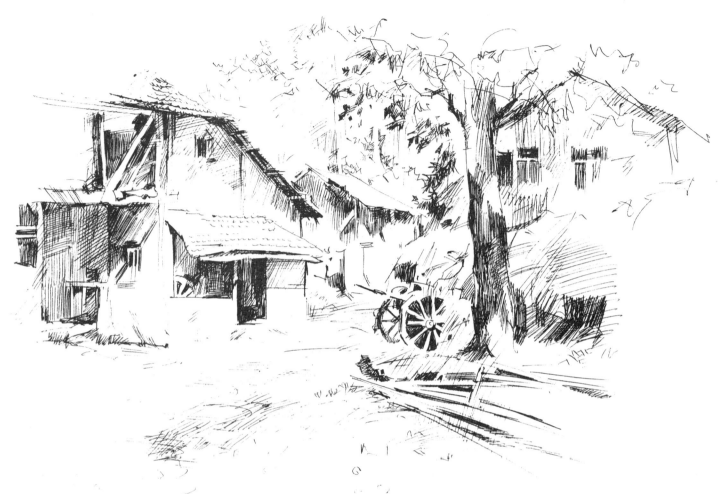

"There is no artist studio, even (that of) a mediocre one, in which a study may not be found superior to his finished works," says Alfred Stevens.

What Alfred Stevens opines is fortunately or rather unfortunately true.

Why does one often experience charm in a sketch or study but not in a painting which is complete?

A sketch is often spontaneous. It is the painter's direct response to a subject he comes across or sees. At that stage, points such as how to do the composition and which technique to use generally do not crop up.

For a viewer, lines present beauty. The lines reveal some definite shapes. On a white paper black lines clearly depict division of space. Such clarity may not always be seen in a completed painting.

Also, only a few lines or shaded masses done with pencil may suggest the existence of an object. The lines in a sketch may be suggestive and stimulate the imagination of the viewer, who may then complete the painting in his own way.

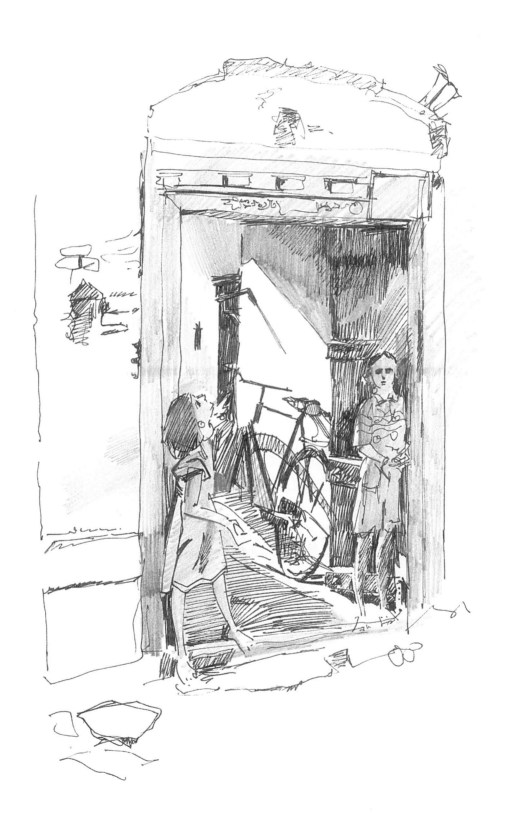

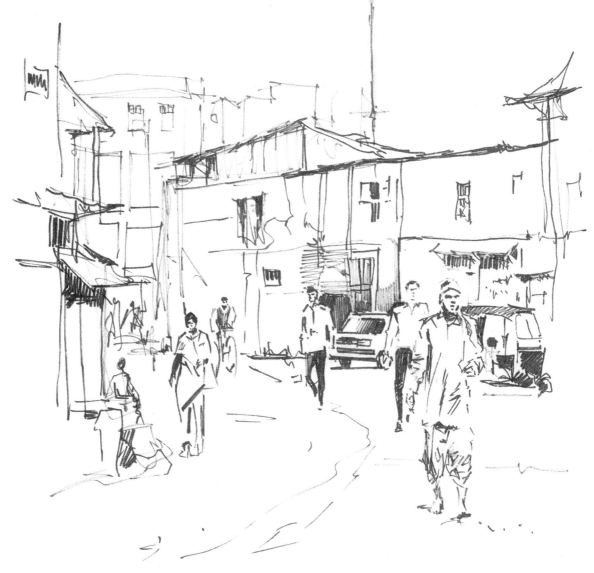

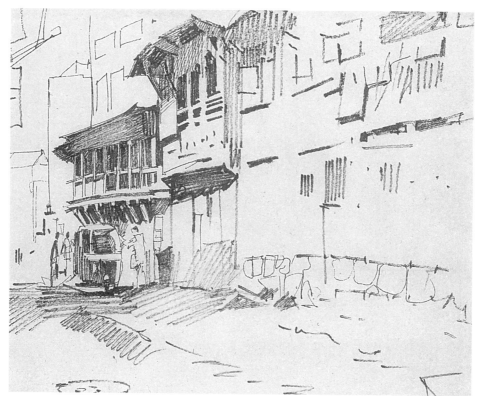

6

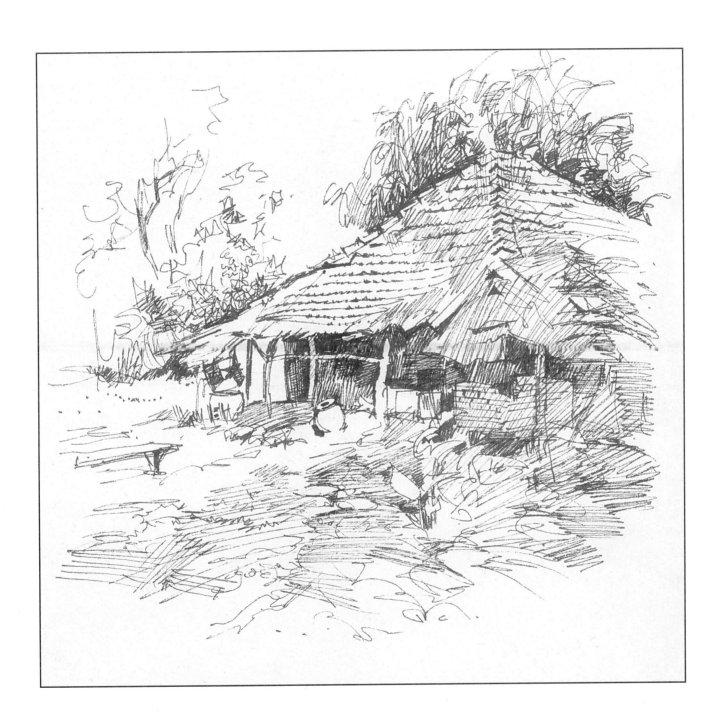

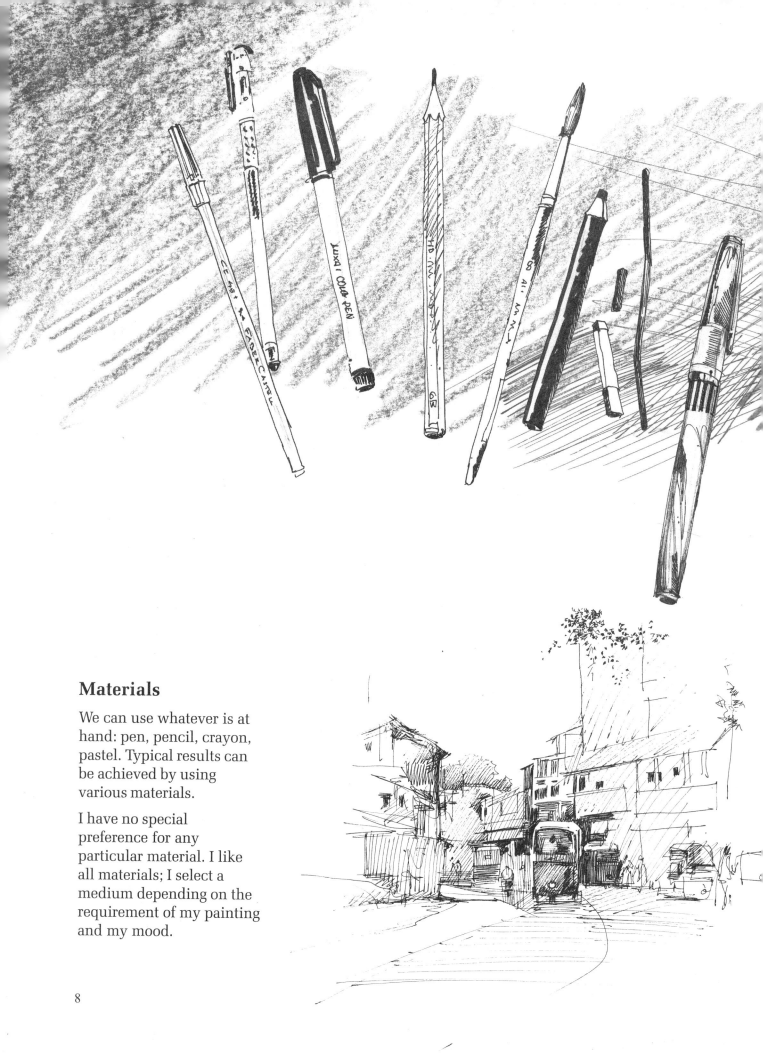

Materials

We can use whatever is at hand: pen, pencil, crayon, pastel. Typical results can be achieved by using various materials.

I have no special preference for any particular material. I like all materials; I select a medium depending on the requirement of my painting and my mood.

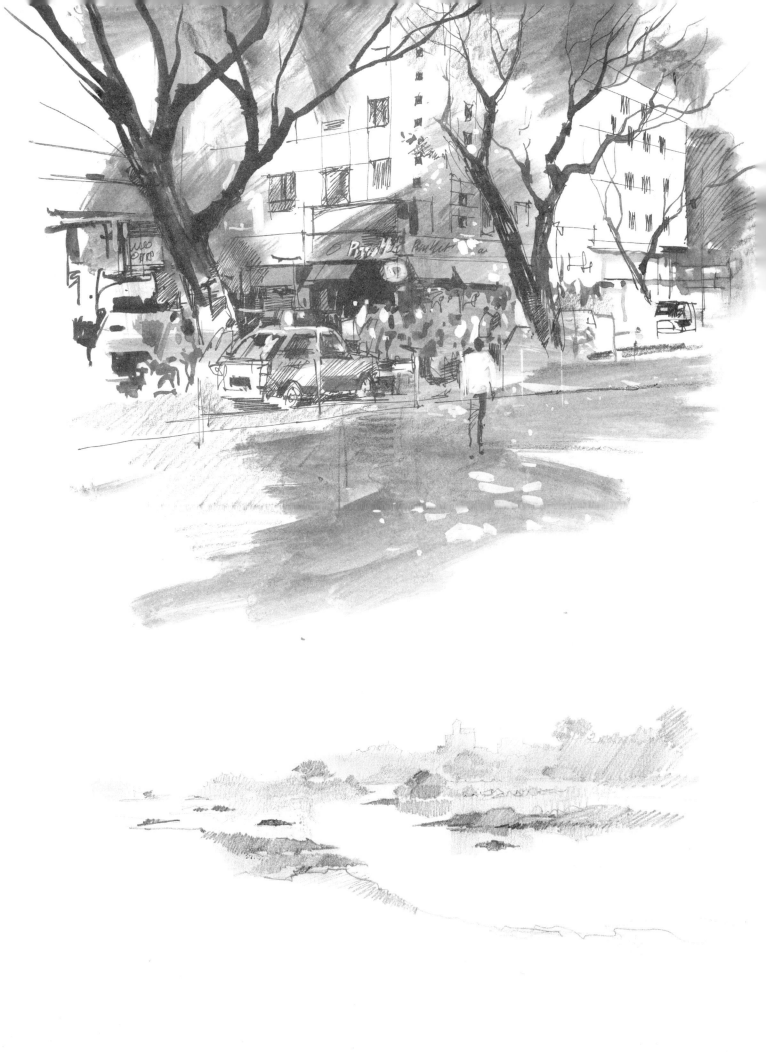

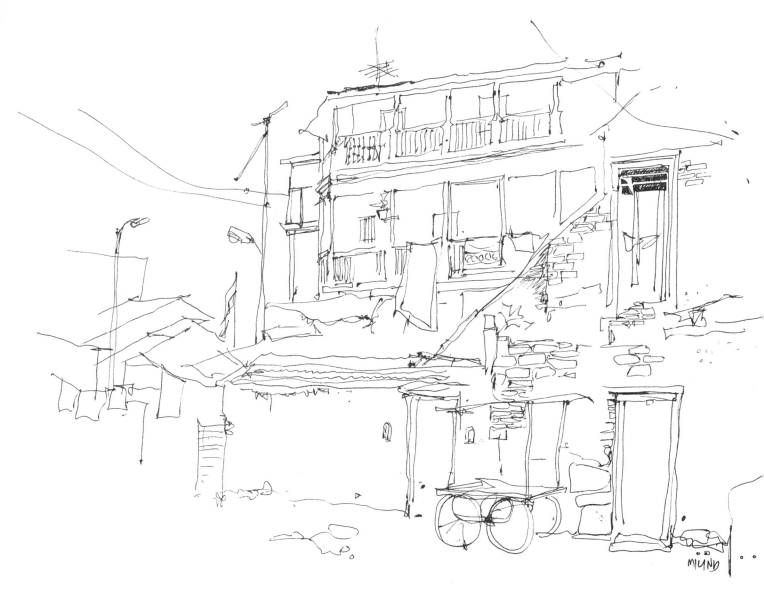

Pen

Earlier, the fountain pen was used extensively for sketching. These days I prefer gel pens. A line drawn with a pen cannot be erased. Sketching is done with minimum necessary lines. It helps to concentrate on the preciseness of drawing. Sometimes we may draw a number of lines. These lines reveal how the sketch came to be developed.

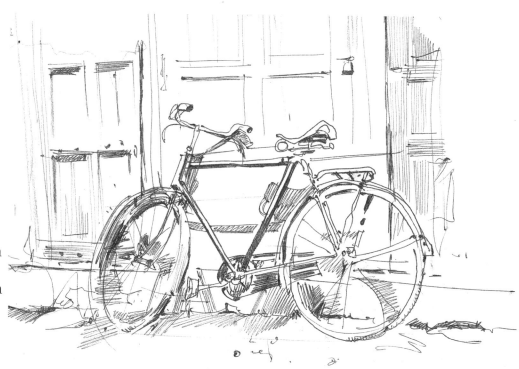

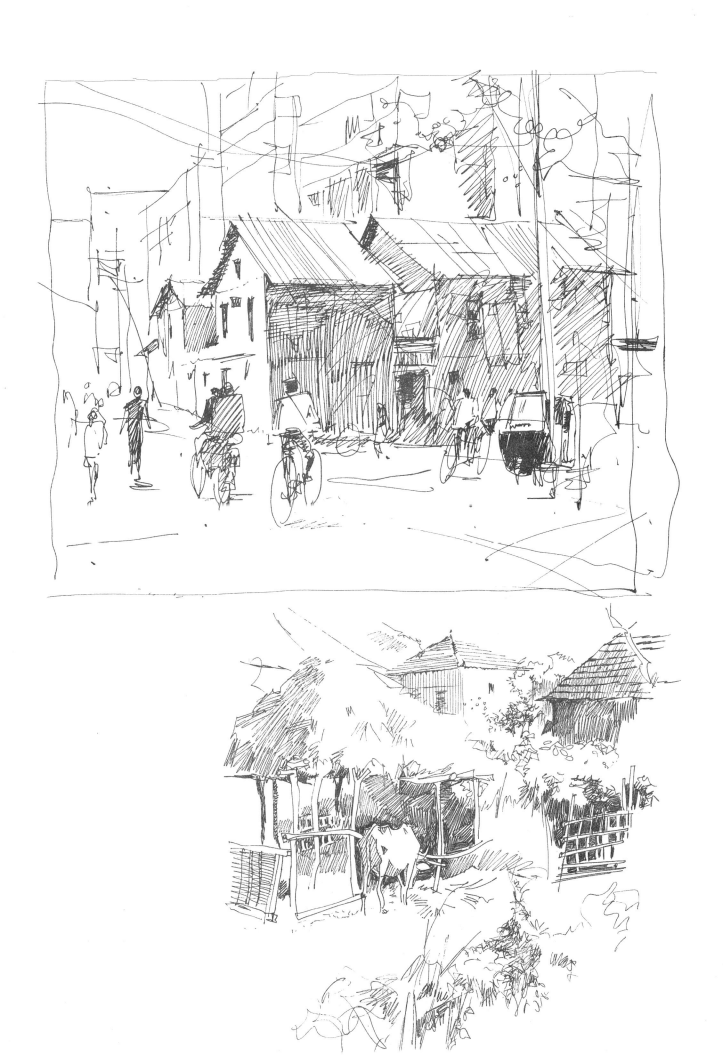

Pencil

Of all the mediums in painting, pencil is the most amenable. Pencil is used by all since childhood. We can depict lightness or darkness in a painting to the extent which we wish to by applying varying pressure on the pencil.

The tone of a picture is more important than colours. One can depict all tones from white to black as per one's wish using a pencil. Such tones can be accomplished only by pencil.

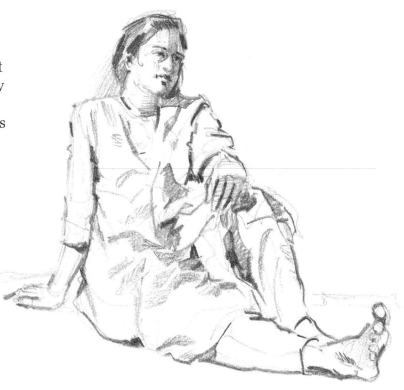

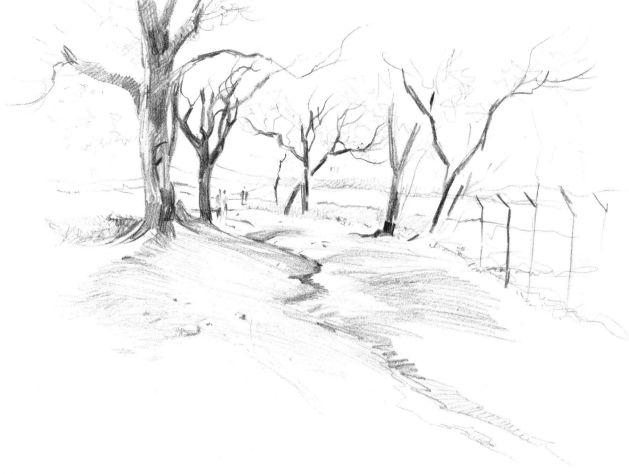

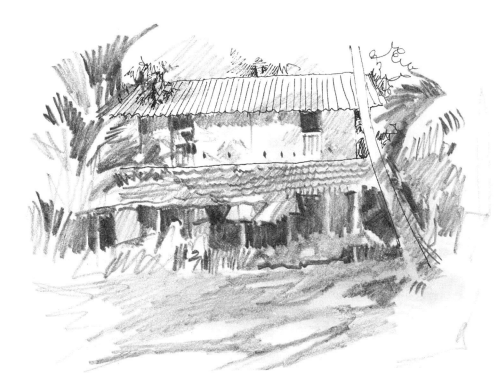

The pencils we use range from a mere HB to 8B in darkness. We can get smudge effect by shading with a pencil with a darkness of more than 2B, and then rub a finger over it.

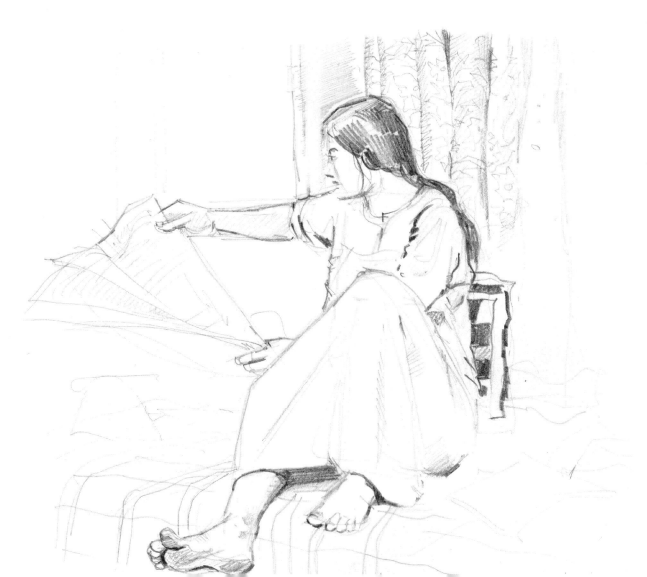

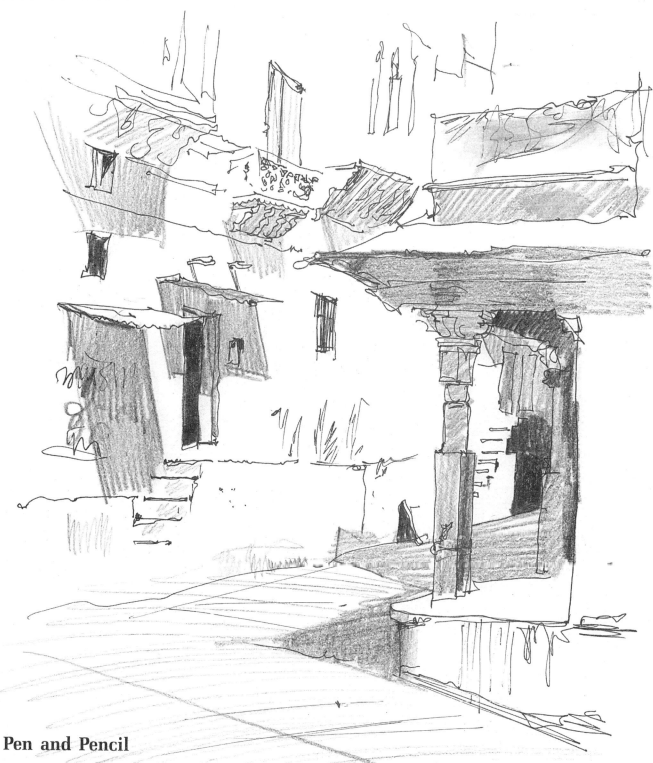

Pen and Pencil

At times, tone and sharp lines are both essential in a painting.

In the painting on the caves at Ellora (opposite page), the relief of the sculpture is important. I felt that a pencil was thus suitable. The dark tone with which I wanted to depict the depth of the painting would not have been possible with pencil alone and thus I also used pen.

In the picture above, I drew lines initially with a pen and then shaded parts of the picture with a pencil. I soon got the desired effect. Basic shapes are quickly realised with lines. Sharp lines cannot be drawn continuously with a pencil as the point gets blunt. I use a pen also at such times.

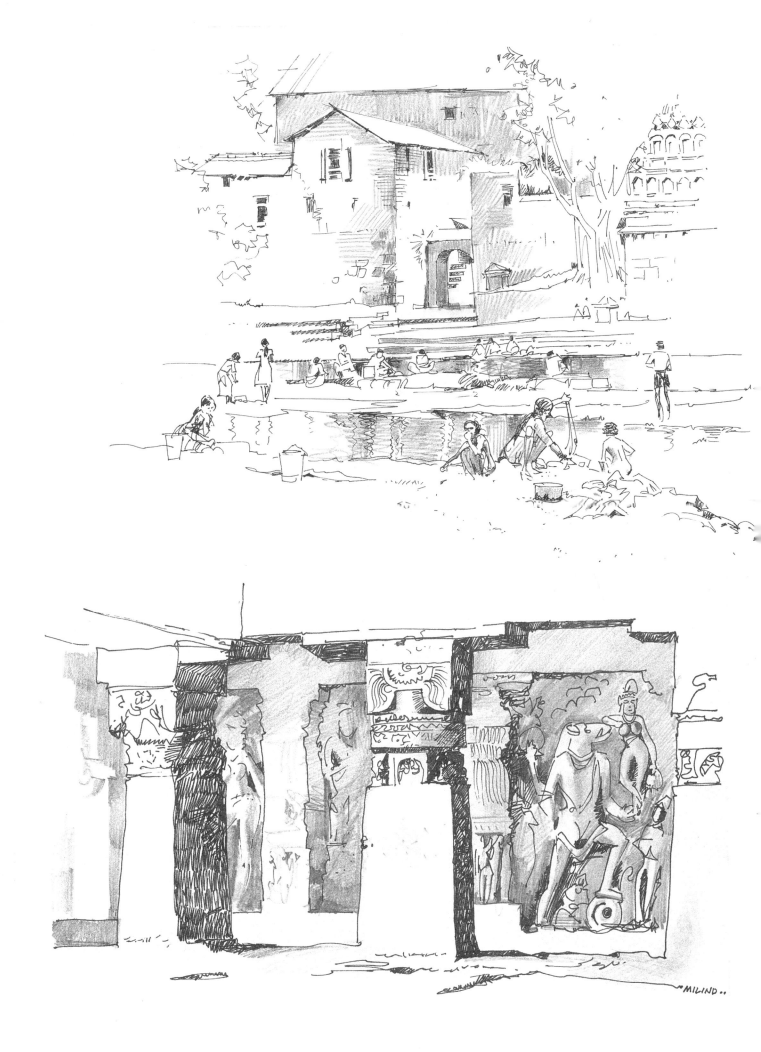

MILIND

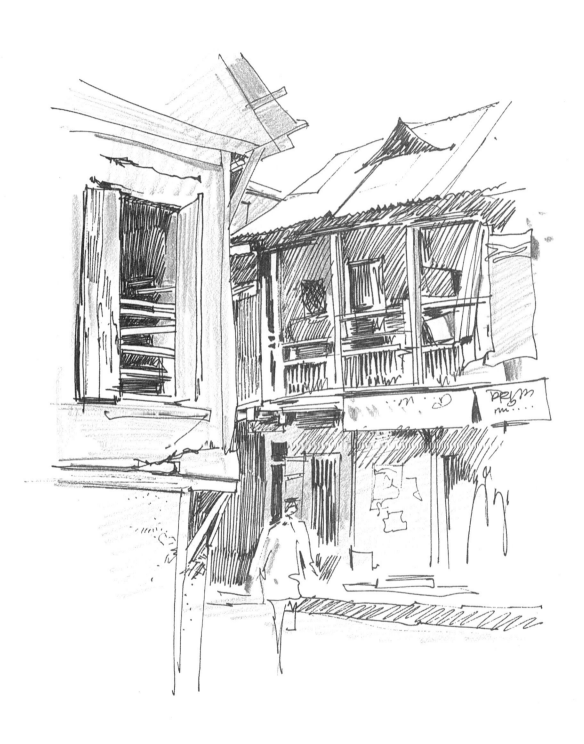

Colour Pencils

Colour pencils are useful to accomplish colour as well as tonal variation. It is however difficult to always achieve a dark tone as per one's expectations. Thus quite often, these pencil sketches give a result of 'high key' pictures.

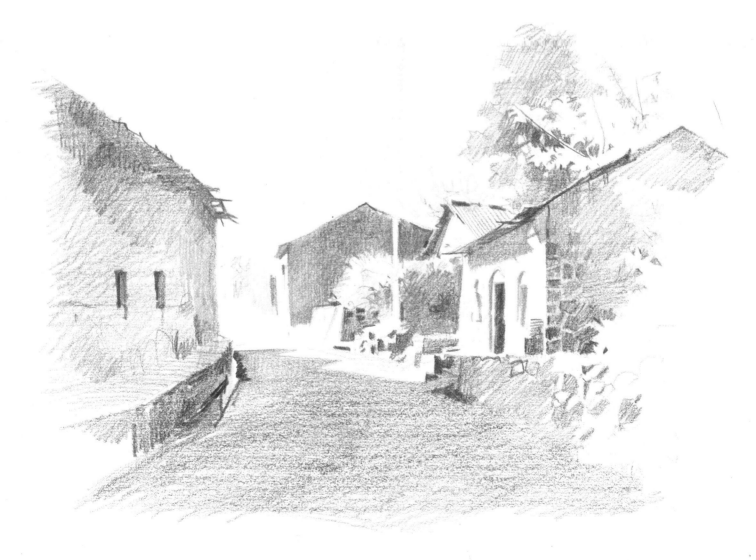

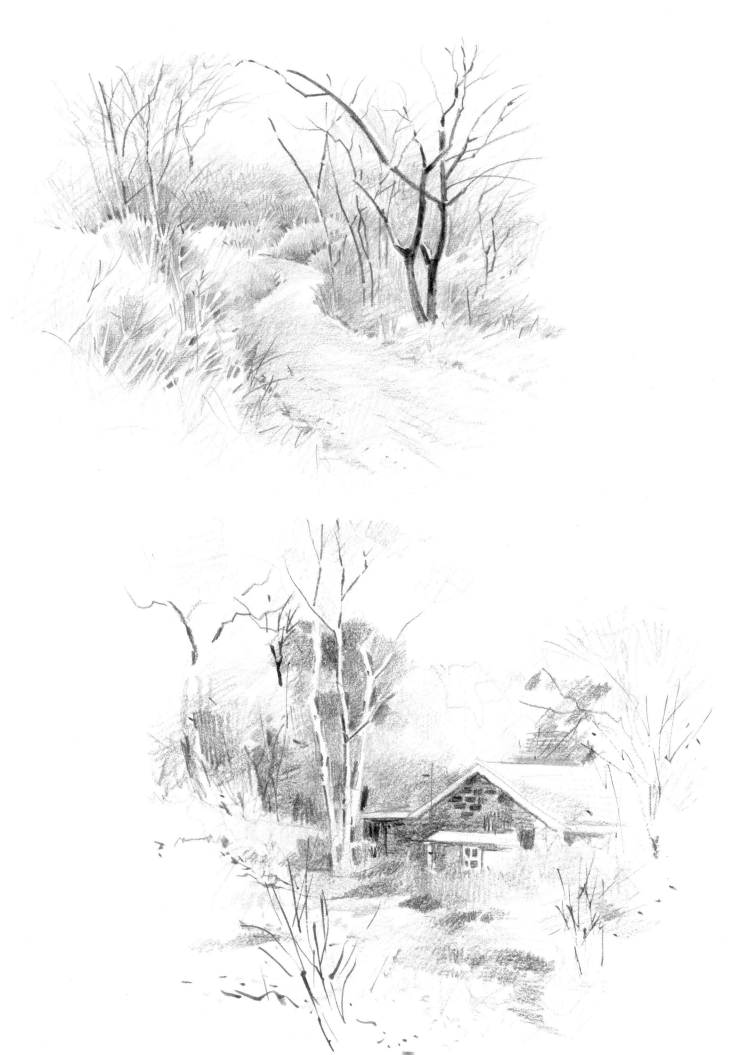

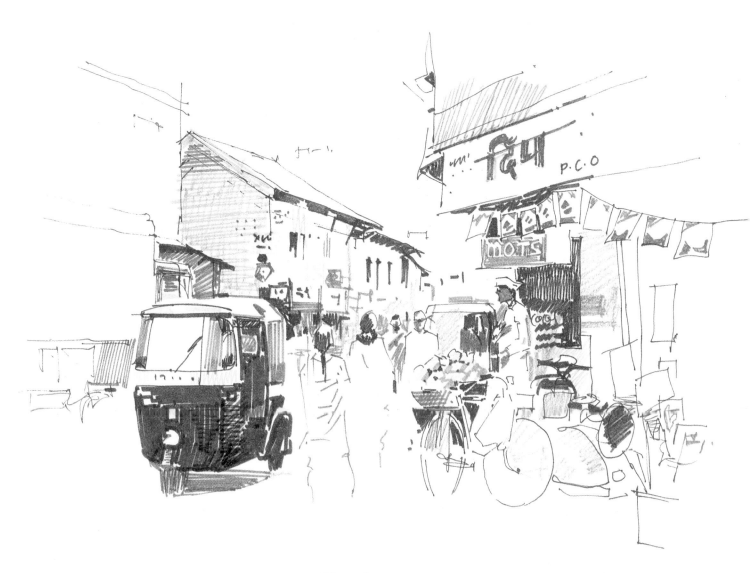

Sketchpens

Sketchpens are characterised by gaudy colours and their speed. Sketchpens are useful to fill in masses after line drawing and hatches. Sketchpens are used to colour what strikes one's mind at once. It is however not possible to accomplish tonal variation as with a pencil. Sketchpens are thus useful to help one to guess tonal values of colours. One can also carry out experiments of optical colour mixing like the Impressionist painters. (Optical colour mixing is getting the effect of a different colour from juxtaposition of strokes of two or more primary colours.)

As only limited and gaudy shades are available in sketchpens, practising with sketchpens is more stimulating.

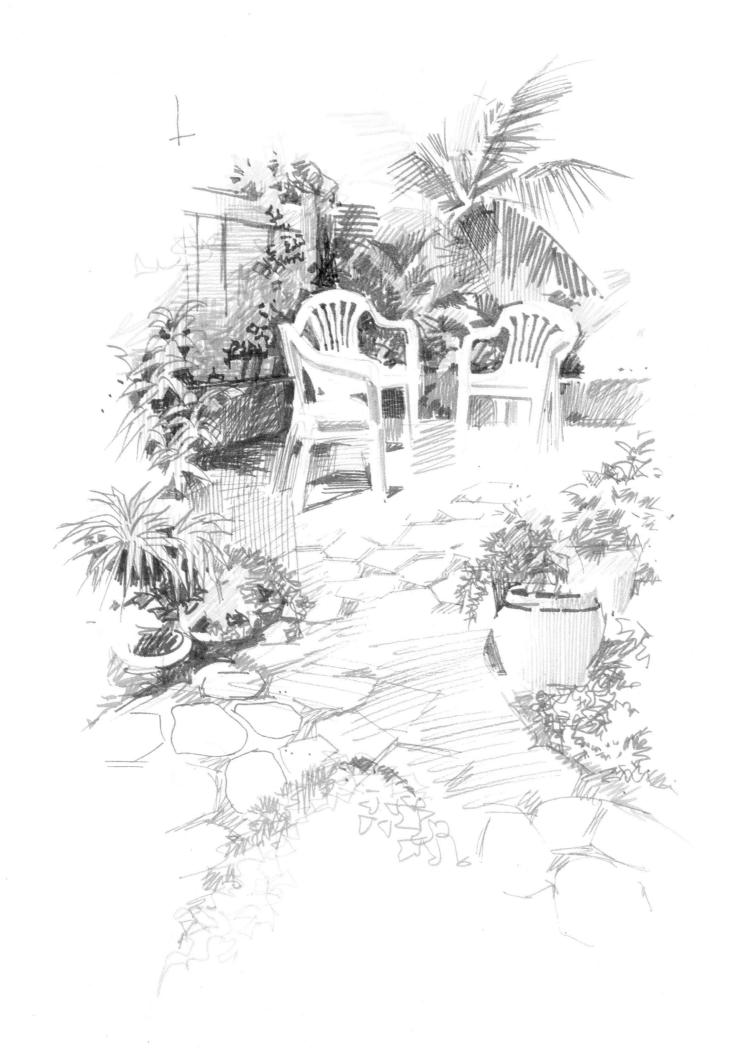

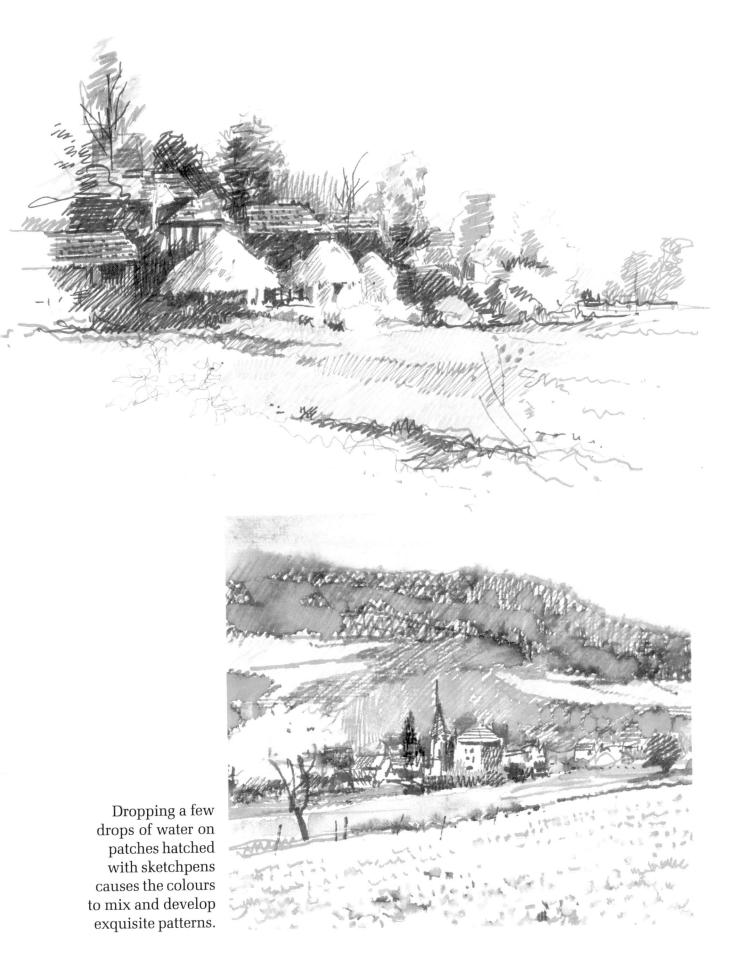

Dropping a few drops of water on patches hatched with sketchpens causes the colours to mix and develop exquisite patterns.

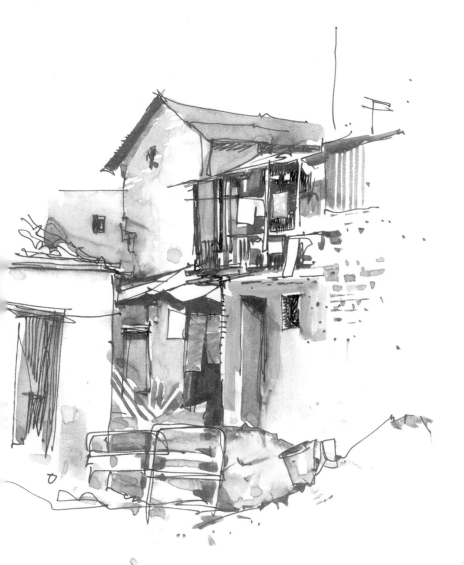

Watercolours

Watercolours are convenient for washes of any tone in any colour. But it is difficult to define the shape of an object with watercolours. In such cases, combining watercolours with pen and pencil while sketching gives the desired effect.

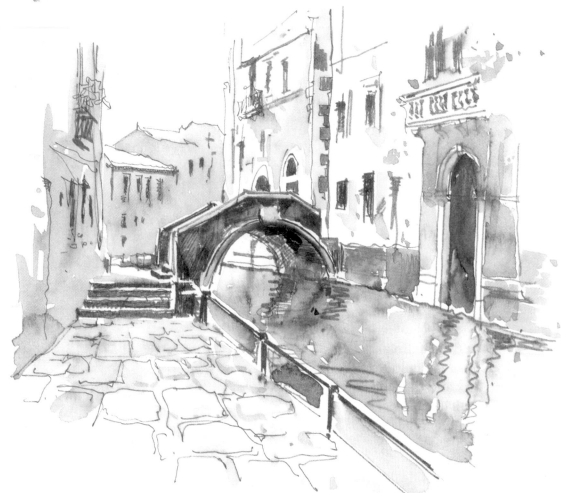

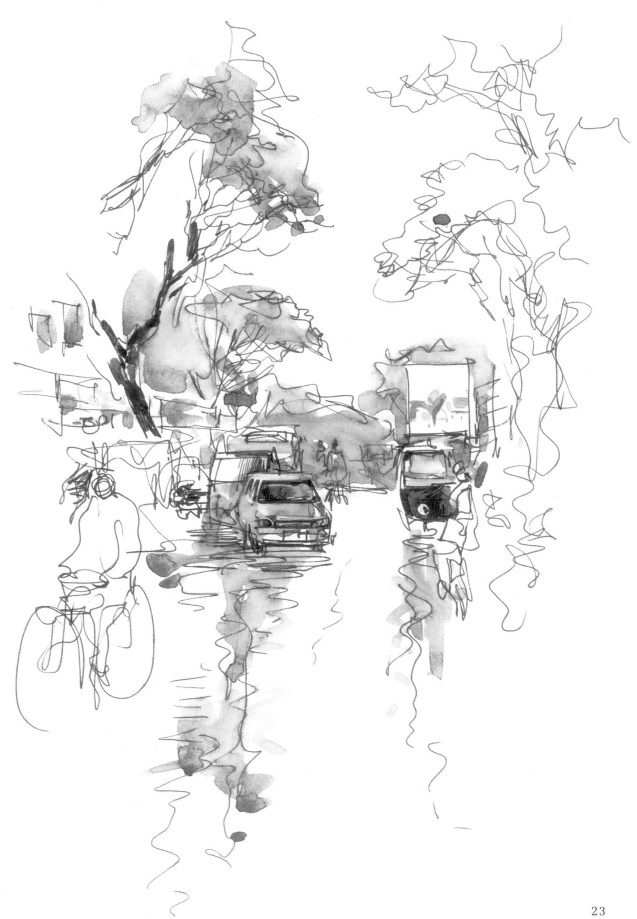

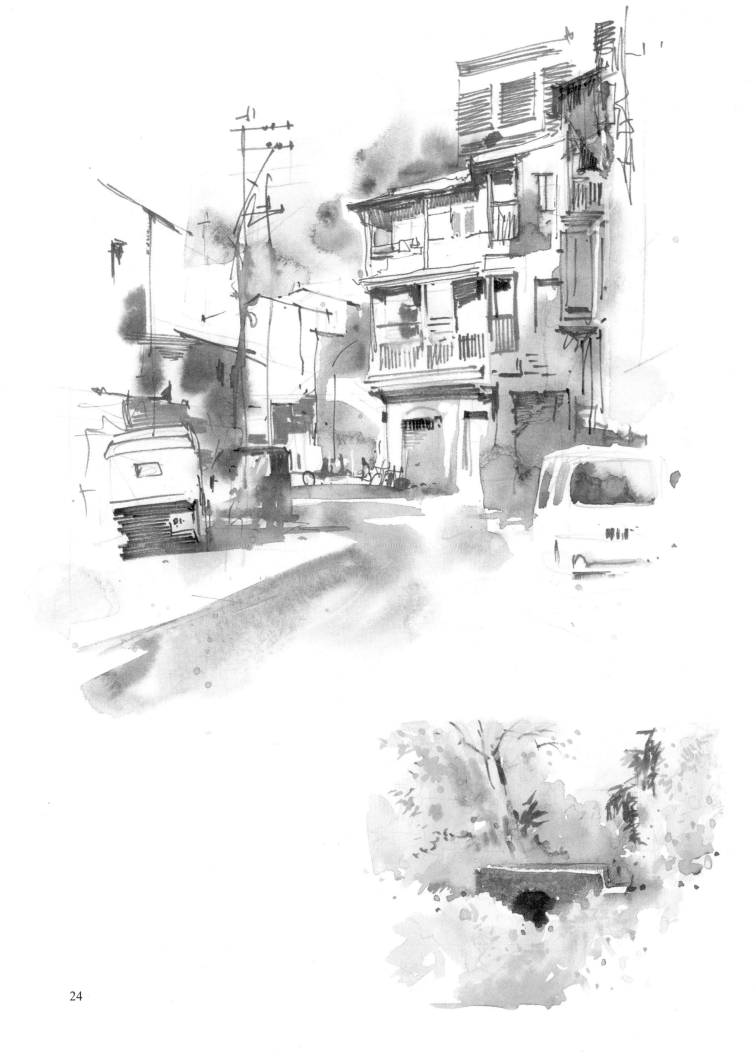

Charcoal and Crayons

Charcoal and Crayons are used to achieve bold and textural quality.

In the picture, the black stone of the old building could have been portrayed with a 6B pencil. As speed is important in sketching, I did it with crayons.

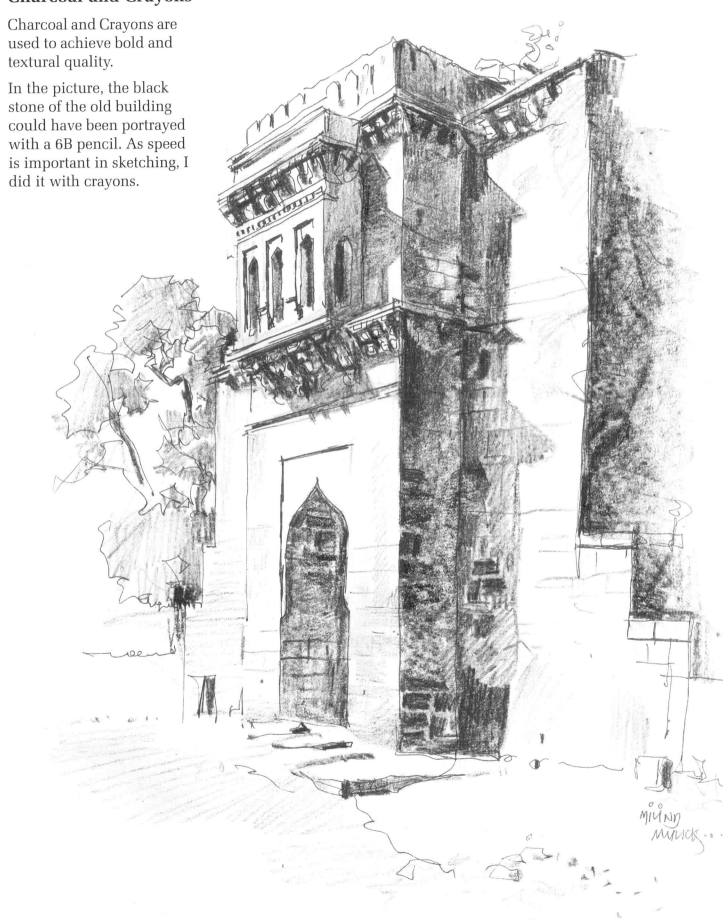

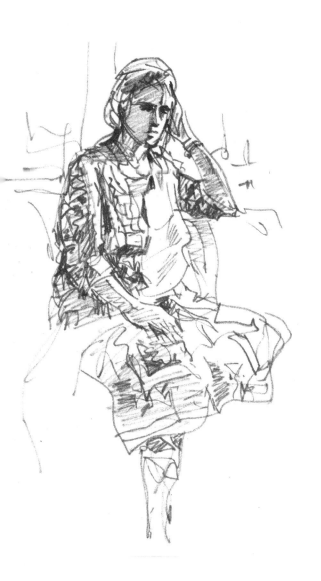

Sketching and Drawing

The first step in painting is sketching or drawing. Drawing is the skill of putting on paper what one sees or perceives in mind.

Let us distinguish between a drawing and a sketch. A sketch is describing a view or an event through images on paper than through words. Exactness or proportion are not as important at this stage as much as whether all that which has to be shown is depicted.

A drawing is more concrete. Here proportionality assumes significance. What is important is not whether it is a landscape or a portrait. The emphasis is on limiting a proportionate shape on paper suitably.

A pencil or charcoal drawing is where the forms are well defined before a painting is complete.

Whether it is a finished drawing characterised by light and shadow, moulding and details or a drawing stimulating one's imagination, the space of different shapes is limited at proper places.

On the other hand whether a sketch is suggestive or detailed, its components always represent those in reality. For instance, a sketch of a roadside bazar will immediately recall the crowd, hawkers, customers, sign boards etc. which mark the real scene. The viewer completes the picture in his mind from his prior knowledge and experience.

It is difficult to state where a drawing begins or where sketch ends. Every sketch includes drawing while a drawing does have a part of a sketch.

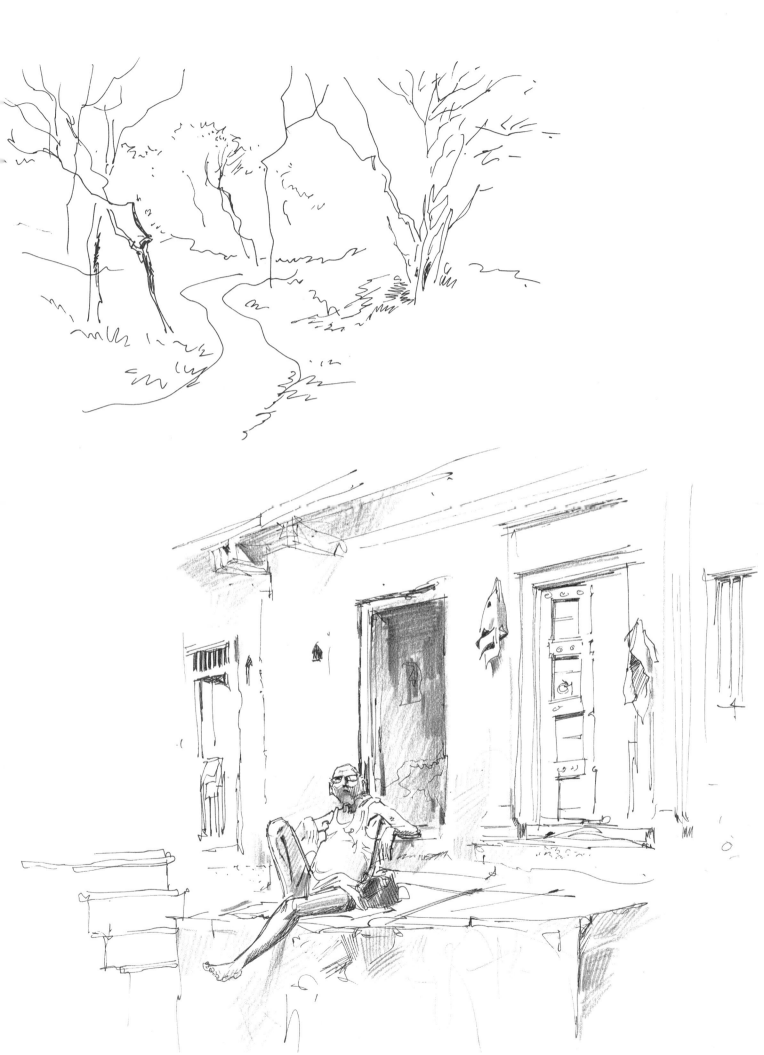

Sketching is a basic and important exercise in the study of painting. It is an ongoing process that forms a major stage in creating a painting.

Practice sketching as much as you can. Sketch anything and everything you see. The basic objective of sketching is practice. In fact practice marks the fundamental difference between sketching and painting. When a musician practises, his aim is to improve his understanding of the composition he is going to present, to enrich the quality of his performance and so on. In a concert when he sings, it is his performance. The standard of his performance depends on his practice. In the same way sketching is the practice while painting or illustration is the performance of the painter.

While doing a sketch how it looks is not important. Do not apply the parameters of a painting to the sketch. In sketching, viewing objects has equal or more importance than doing pictures. Concentrate more on how an object appears than the manner in which the painting will take shape.

Use any convenient means to depict on paper what you see. For instance, while showing an object, house, human form, mark on the paper whichever lines you wish to use for reference.

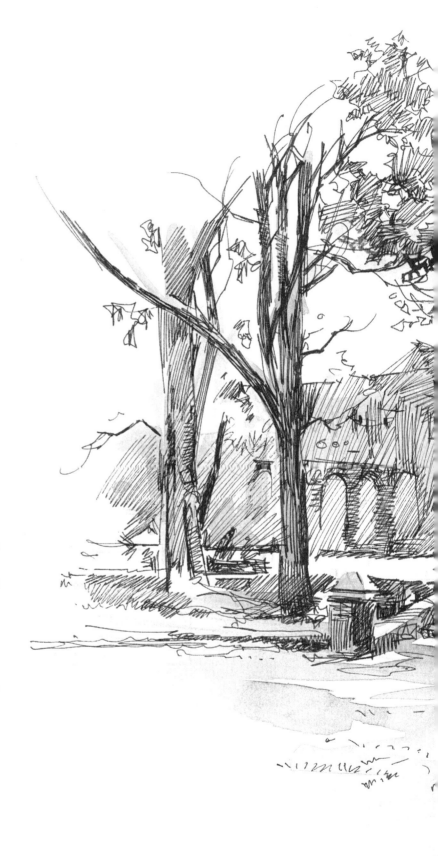

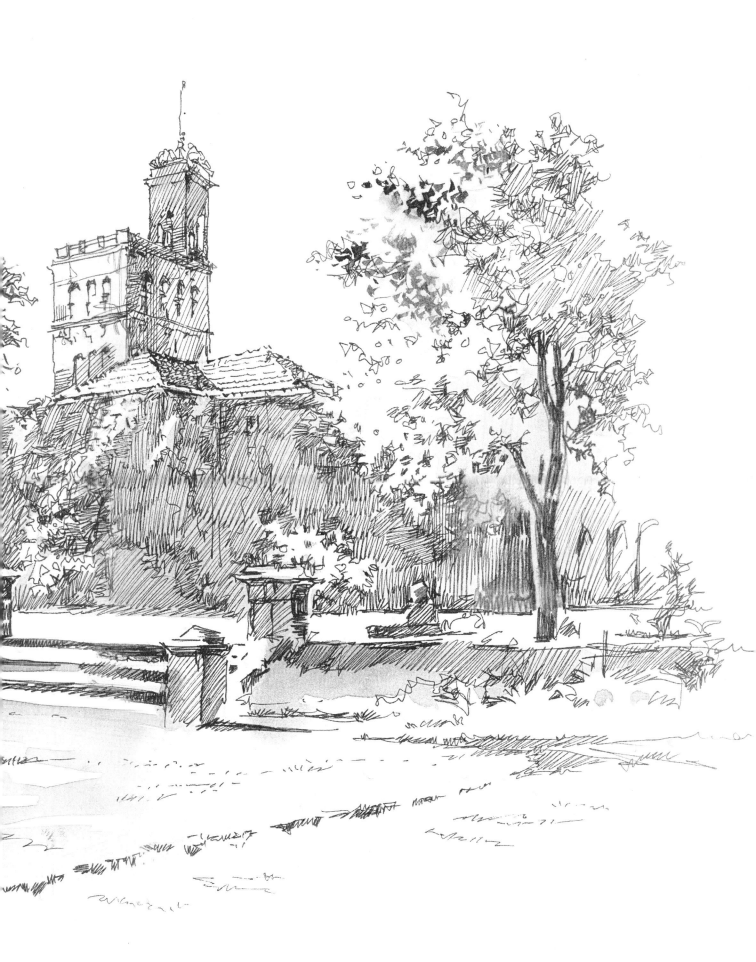

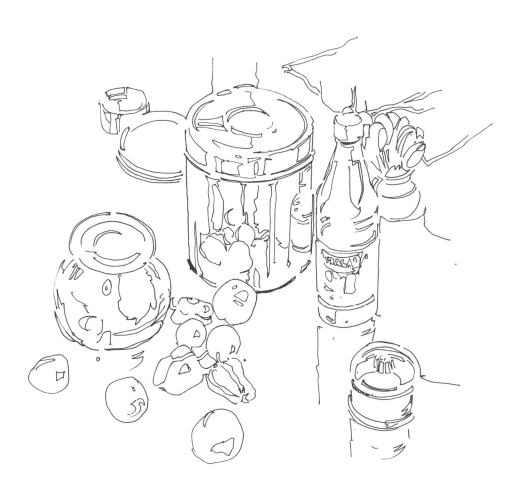

Types of Sketches

1. Sketch done for practice.

2. Sketch as a study or preparatory to a painting. This may be a thumbnail or detailed.

3. Sketch as an independent work of art.

The methods which I use for sketching are mentioned below. While sketching one transforms what one sees into a two-dimensional figure. As stated earlier, viewing is a major step in sketching. The point is : how does one view? In other words, from where and how does one begin to draw?

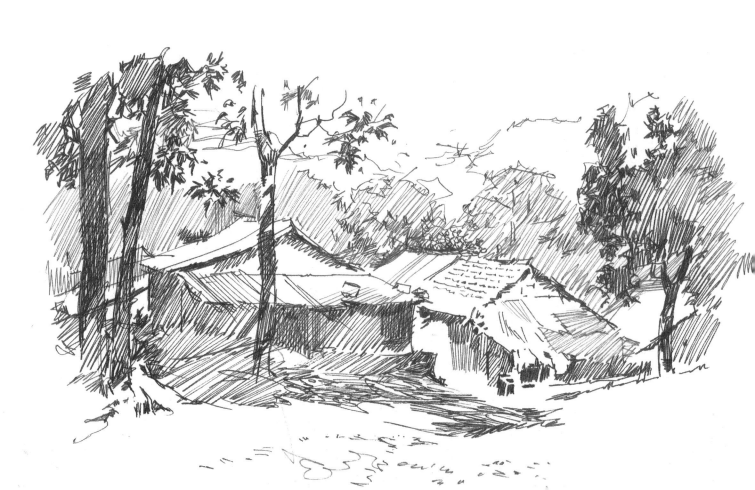

Beginning with one component

In this method of drawing one begins with a component which one feels important in the scene one has in mind. One then relates other shapes with this component and depicts them. In this method one moves radiily outwards beginning with one component.

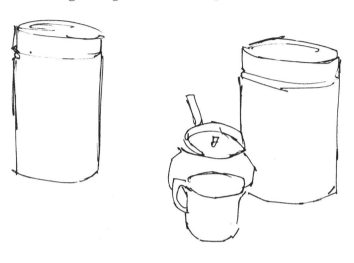
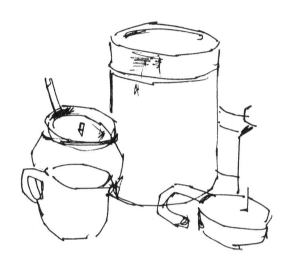

Division of Space

Paper is a two-dimensional surface. Assuming what one sees is also an image on a two-dimensional framework, one divides space on the paper. The components are depicted keeping in mind the outer frame.

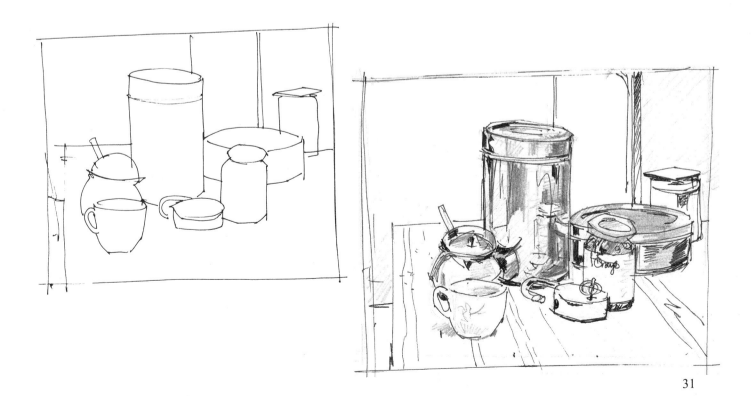

Outline Shape

In this method one draws the outline of a shape by beginning at any point. It is expected that one draws the shape without lifting the pen as far as possible. One can practise doing negative shapes. That is depicting a shape between two branches while drawing branches of a tree. Similarly doing the top of a branch will suggest the middle branch. Drawing negative shapes, as the technique is called, helps one to visualise what one sees in two dimensions.

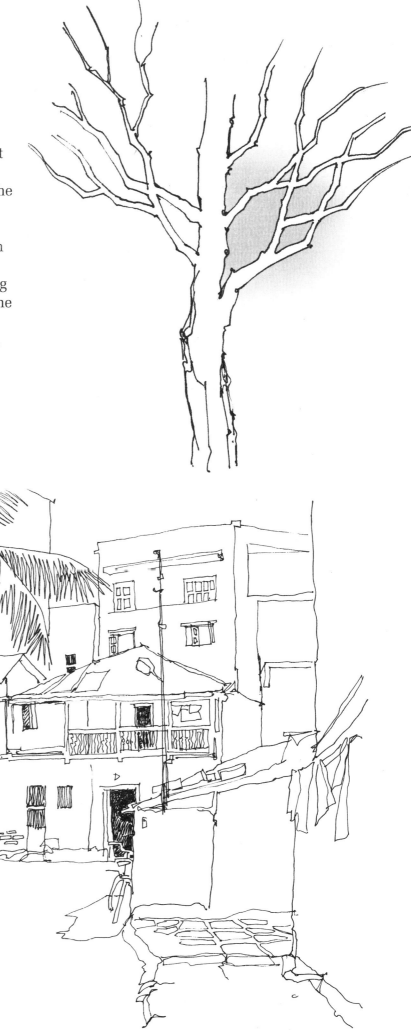

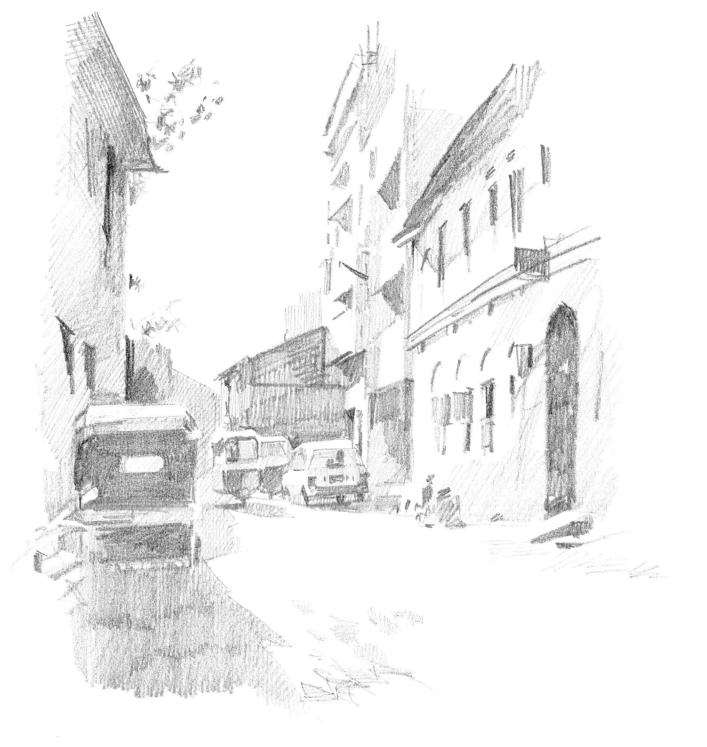

Tonal masses

Here sketching is done by avoiding lines and by filling in tonal masses.

In reality, lines do not exist. Limits of forms and shapes are delineated by lines.

This method helps to understand tones in a view.

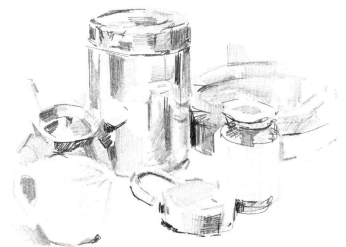

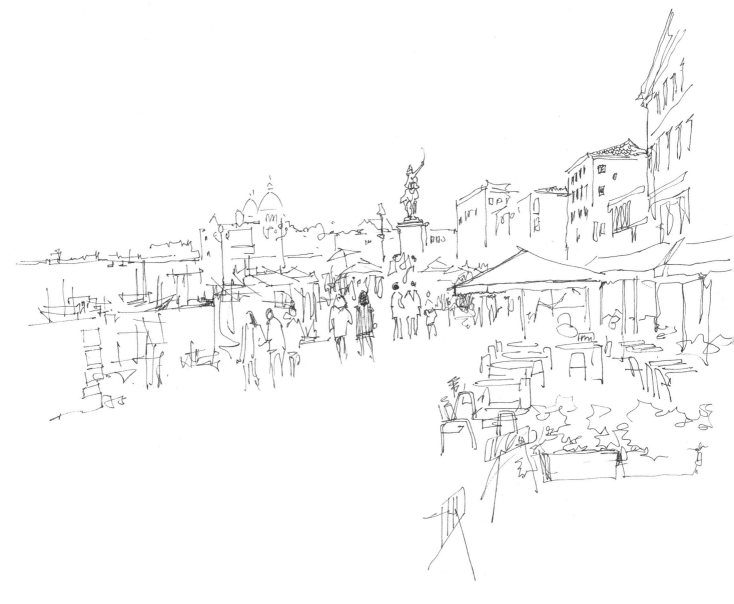

Fast sketches

This method is useful to show only the mood in a still or moving view. Curved and continuous lines are better drawn when they are done fast. Try sometimes fast sketching. Such sketches look exciting. But in case a novice not be able to maintain proportion, the work is meaningless.

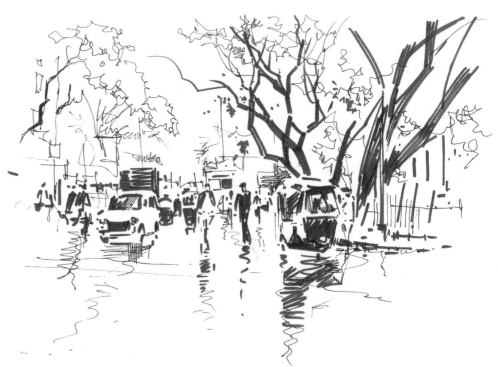

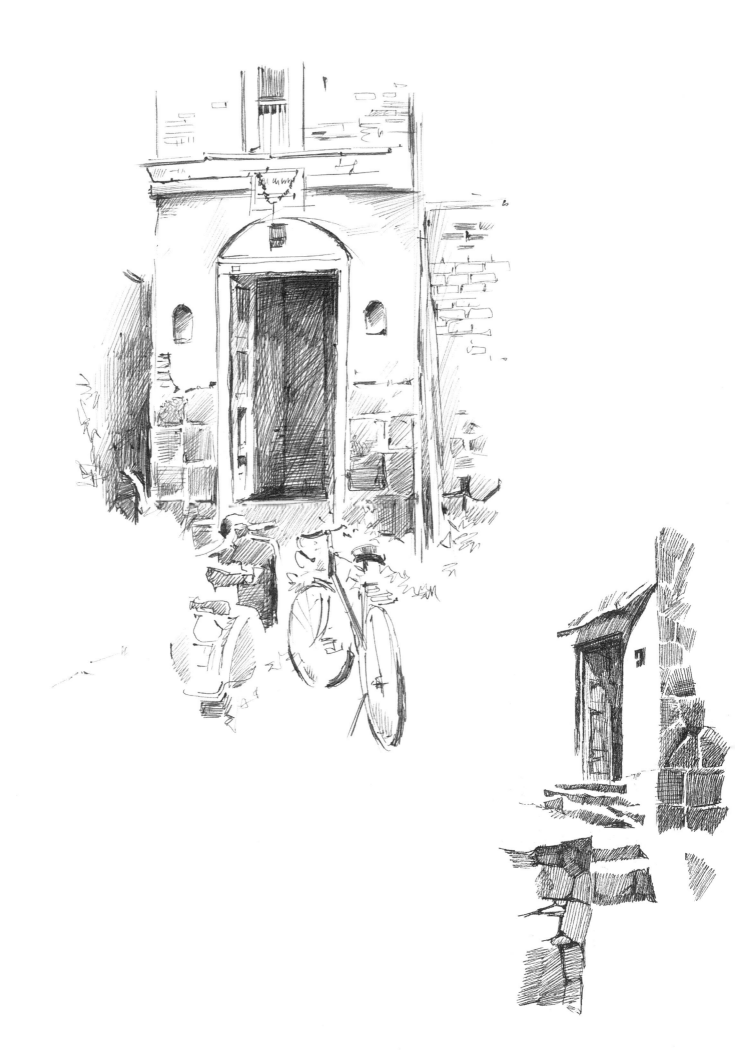

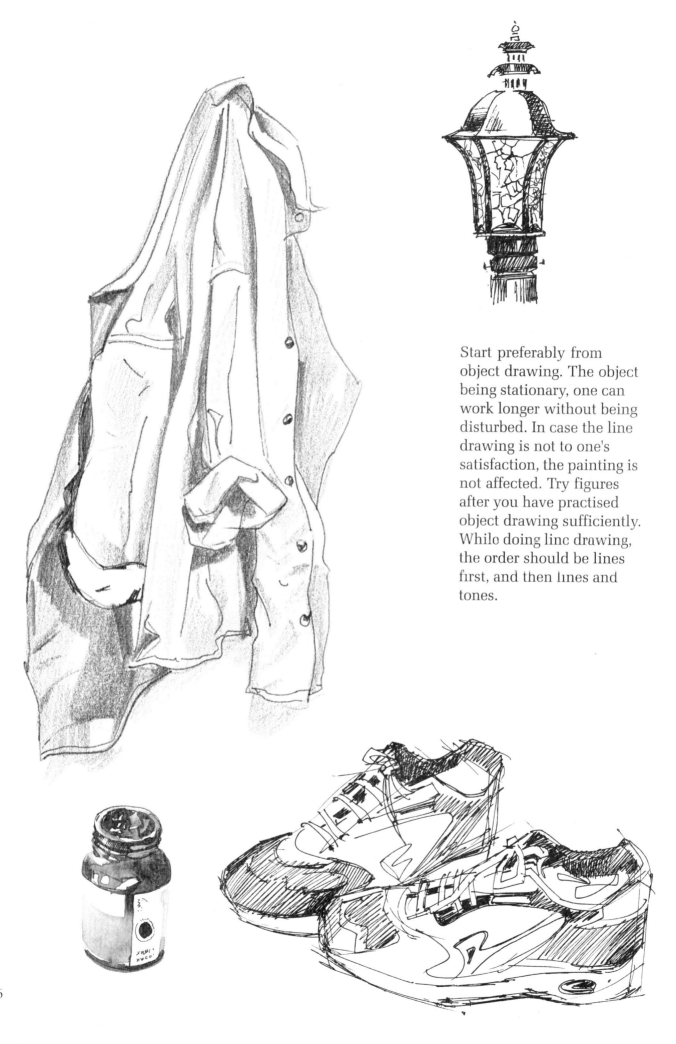

Start preferably from object drawing. The object being stationary, one can work longer without being disturbed. In case the line drawing is not to one's satisfaction, the painting is not affected. Try figures after you have practised object drawing sufficiently. While doing line drawing, the order should be lines first, and then lines and tones.

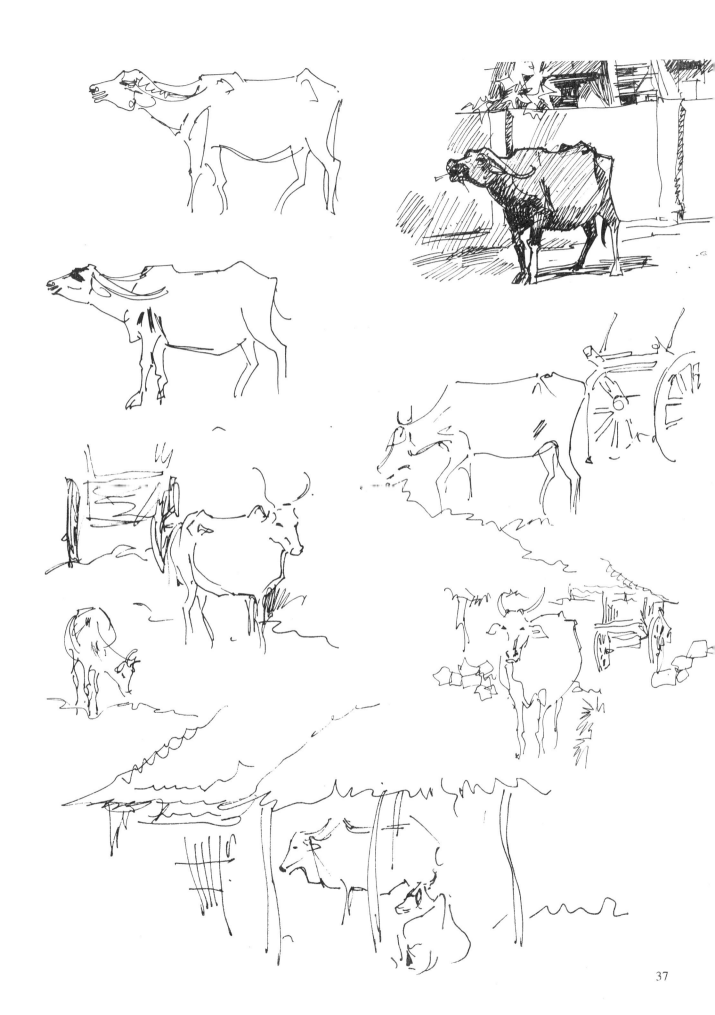

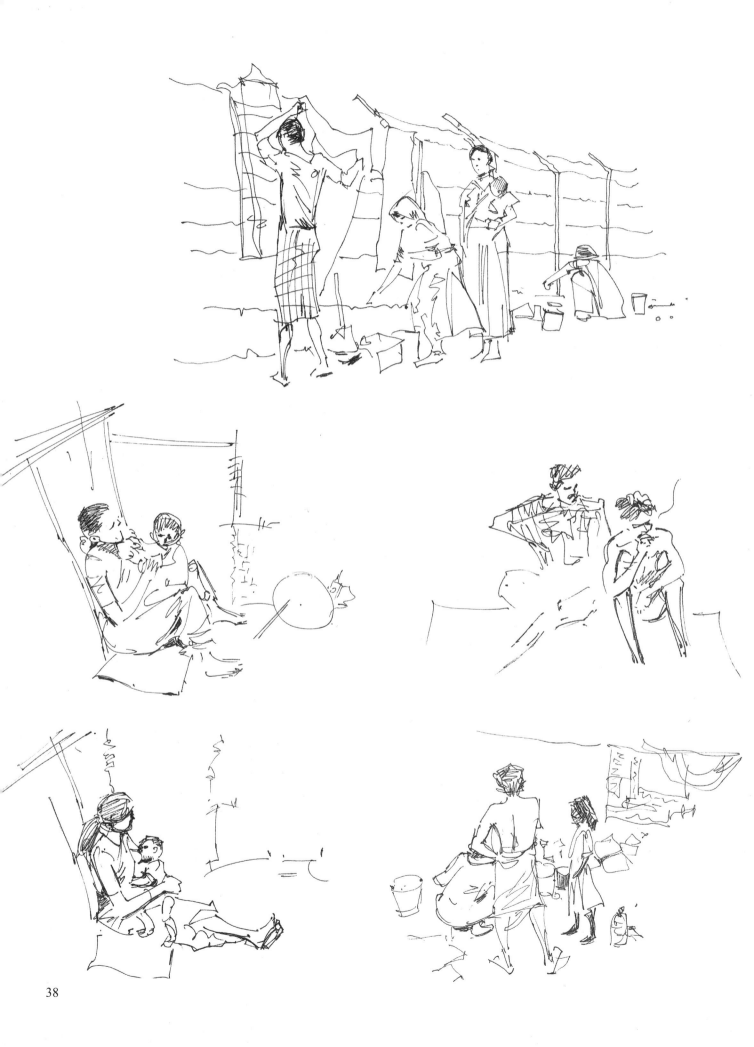

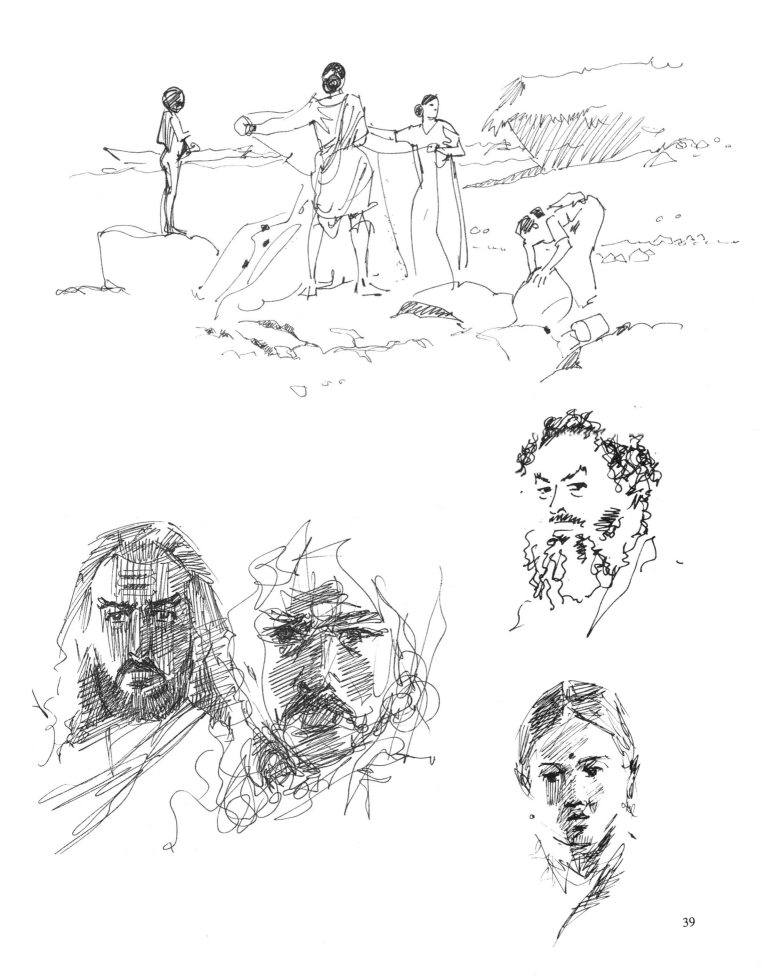

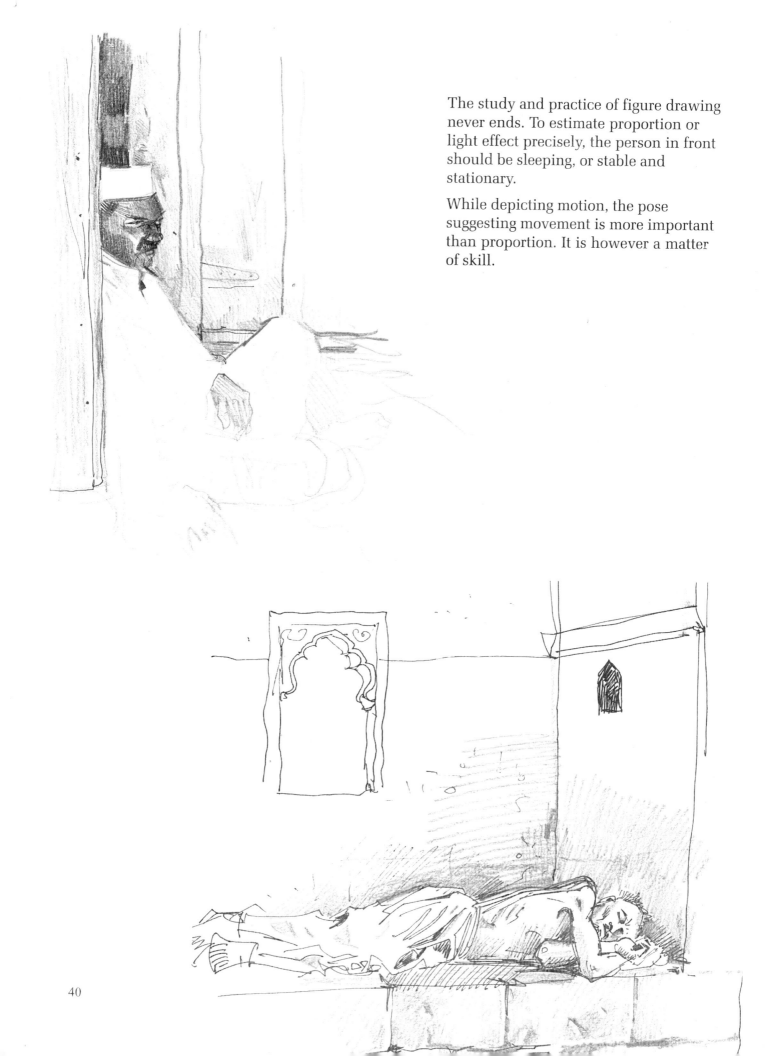

The study and practice of figure drawing never ends. To estimate proportion or light effect precisely, the person in front should be sleeping, or stable and stationary.

While depicting motion, the pose suggesting movement is more important than proportion. It is however a matter of skill.

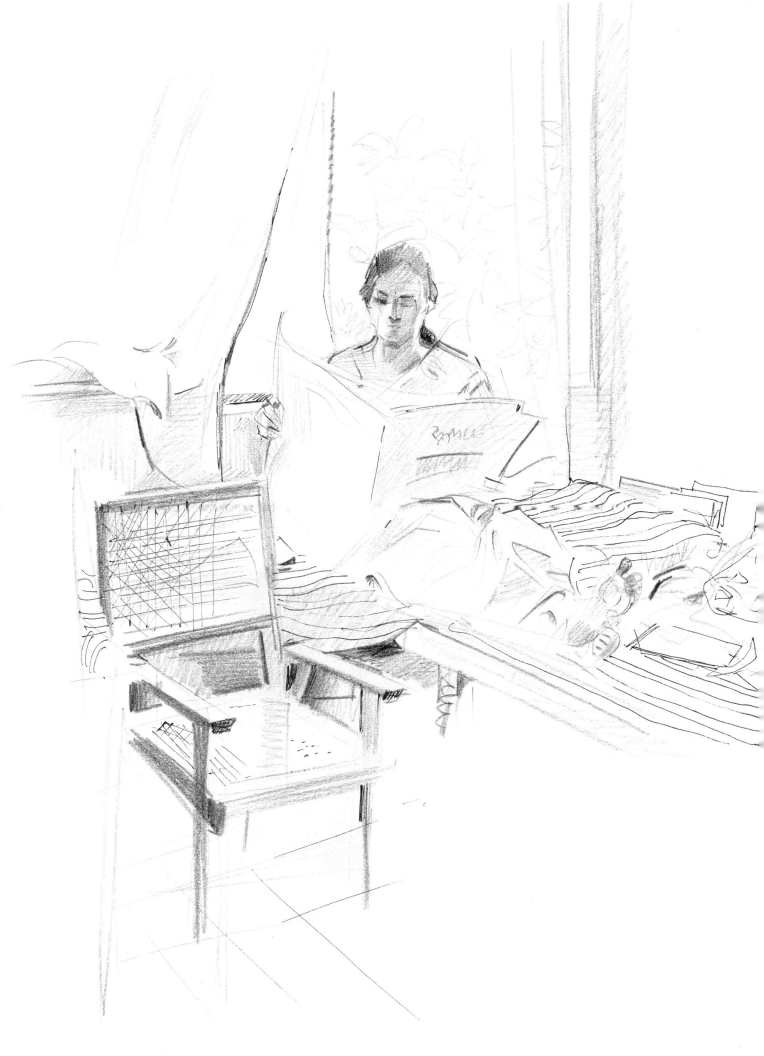

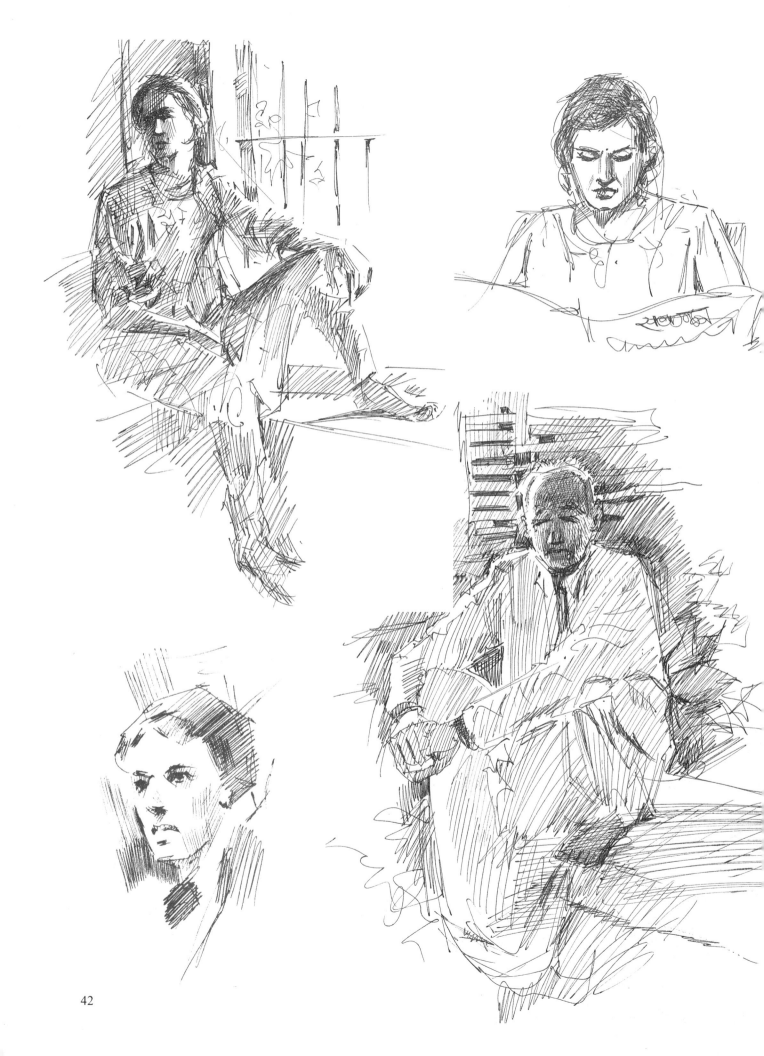

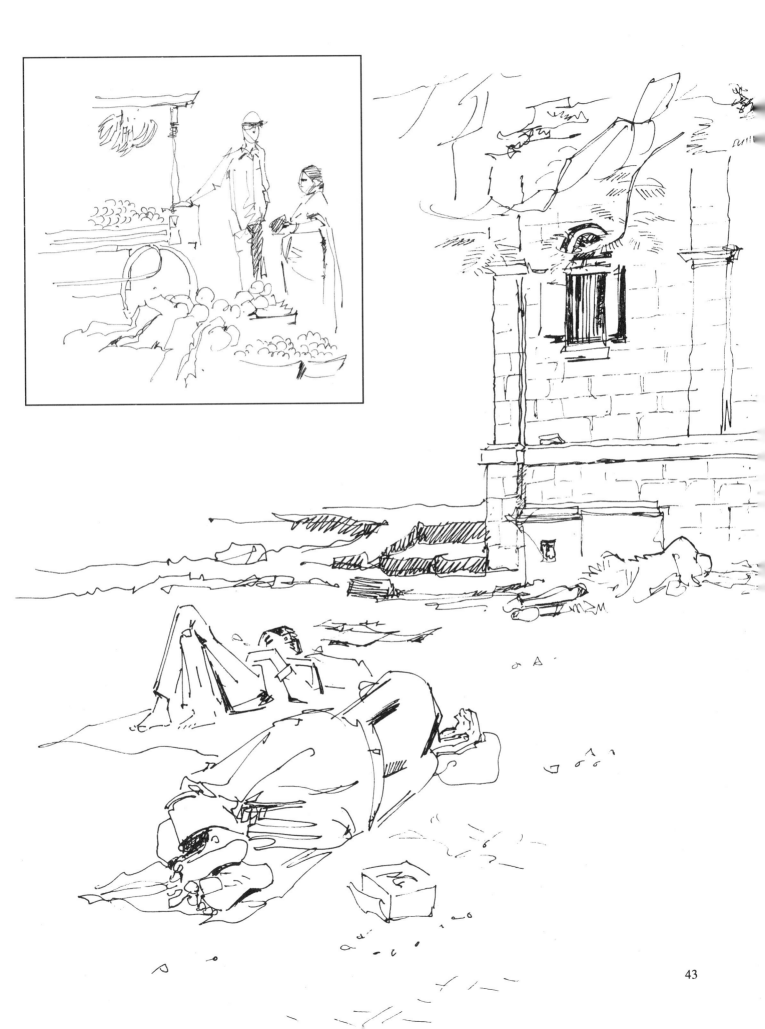

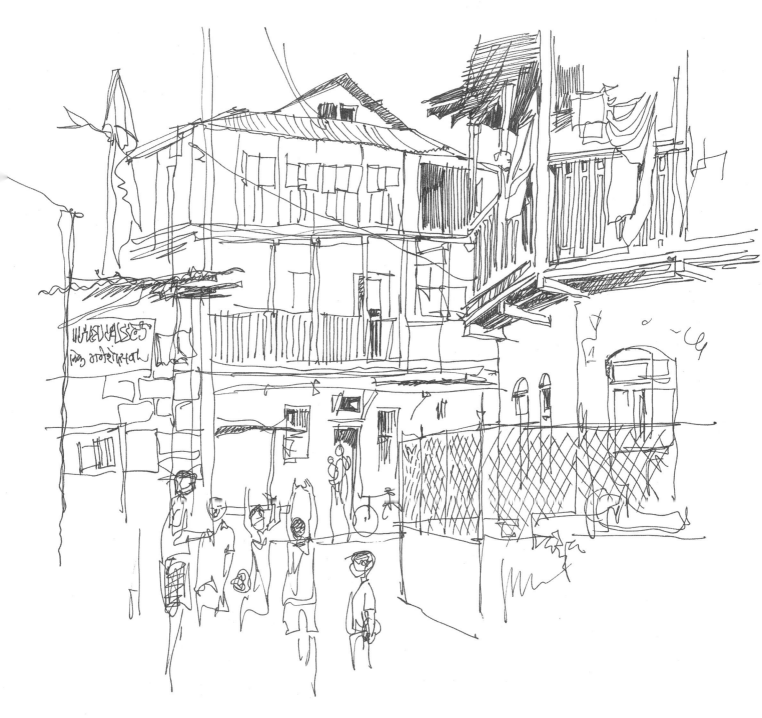

The presence of human forms is seen in different manner. In the picture above, the children playing near the dilapidated building put life into the scene; otherwise the building would have appeared a relic. On the opposite page, the people represent crowd. On their own, they are not significant. Hence only the silhouettes have been marked. The lines of children suggest motion while those of the people the state of being stable.

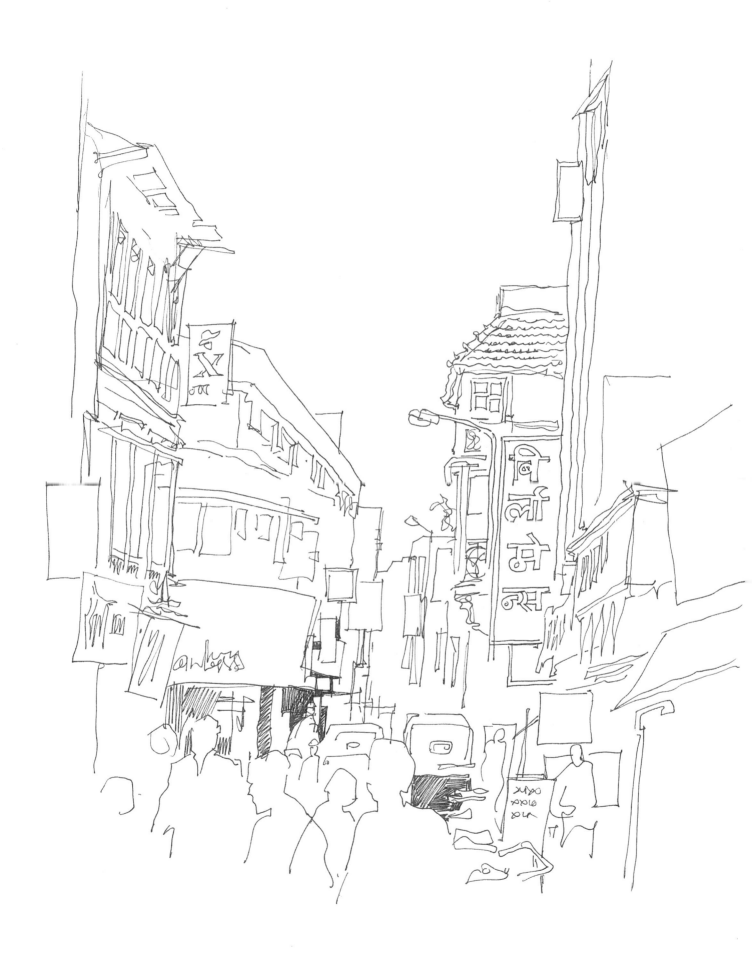

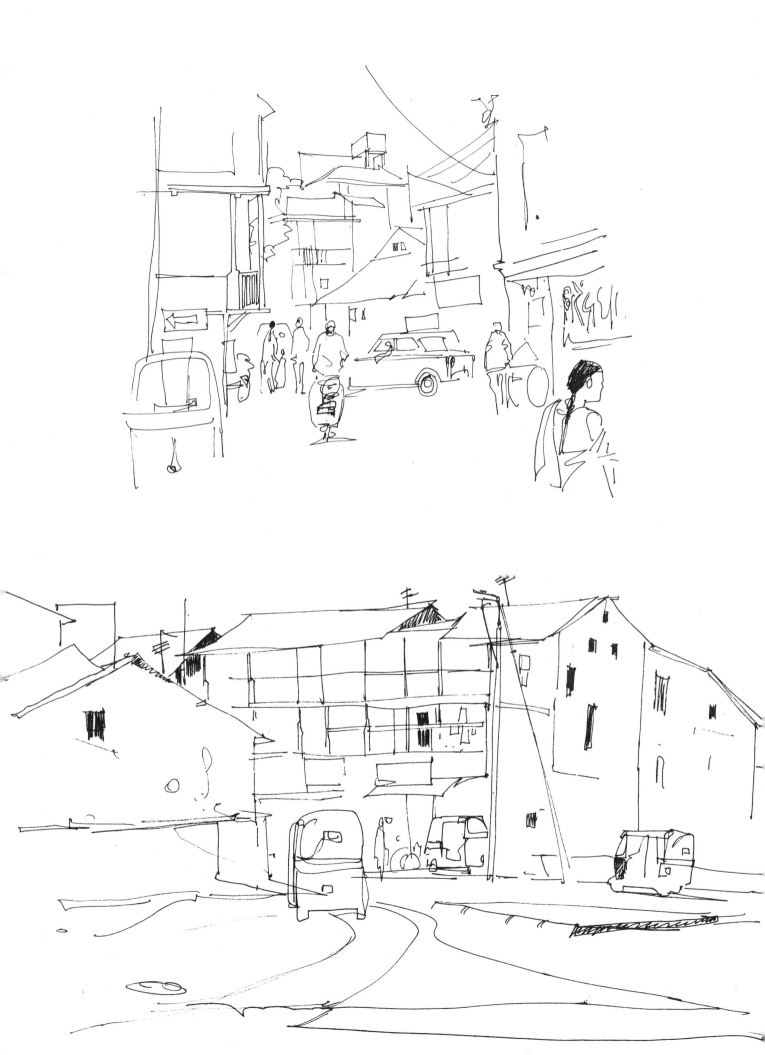

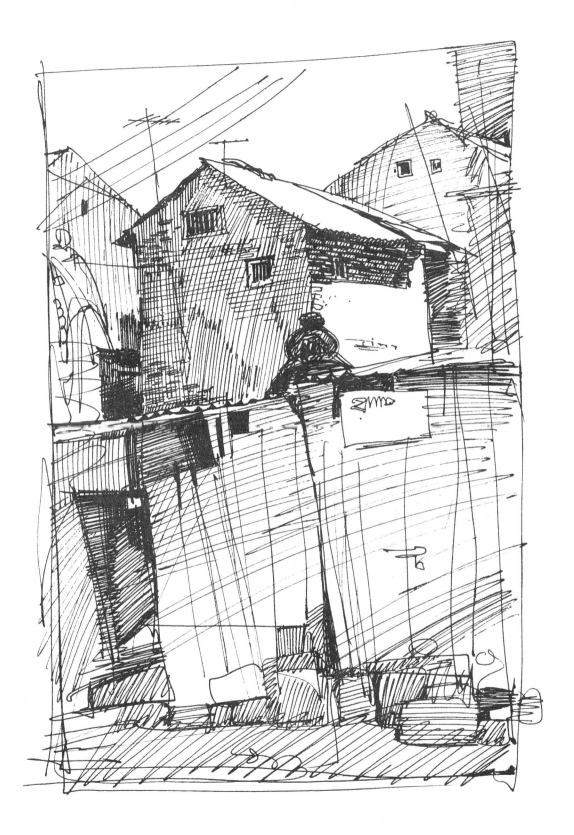

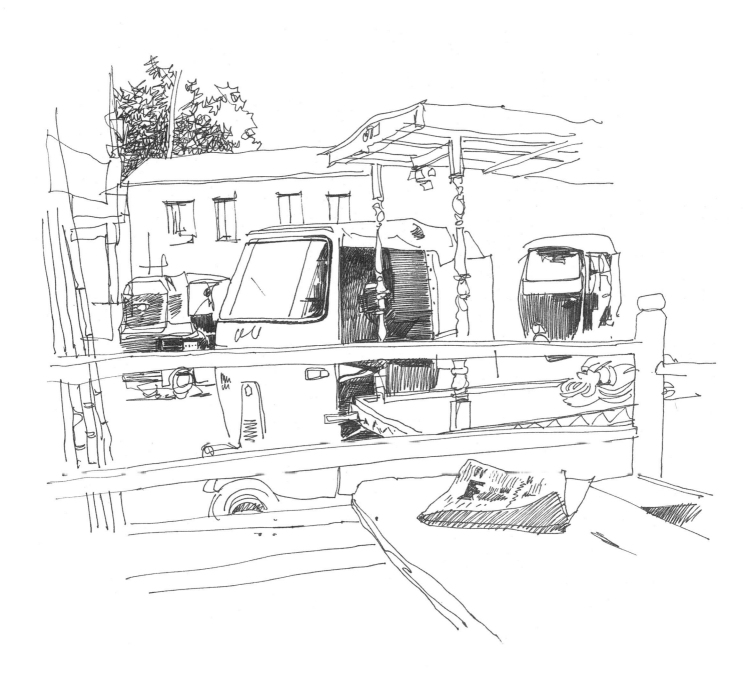

When we depict more than one object in a scene, our attention is drawn to the shapes of each component and their interrelations than the shape of and details in any one object. It helps us to develop our sense of space division and composition.

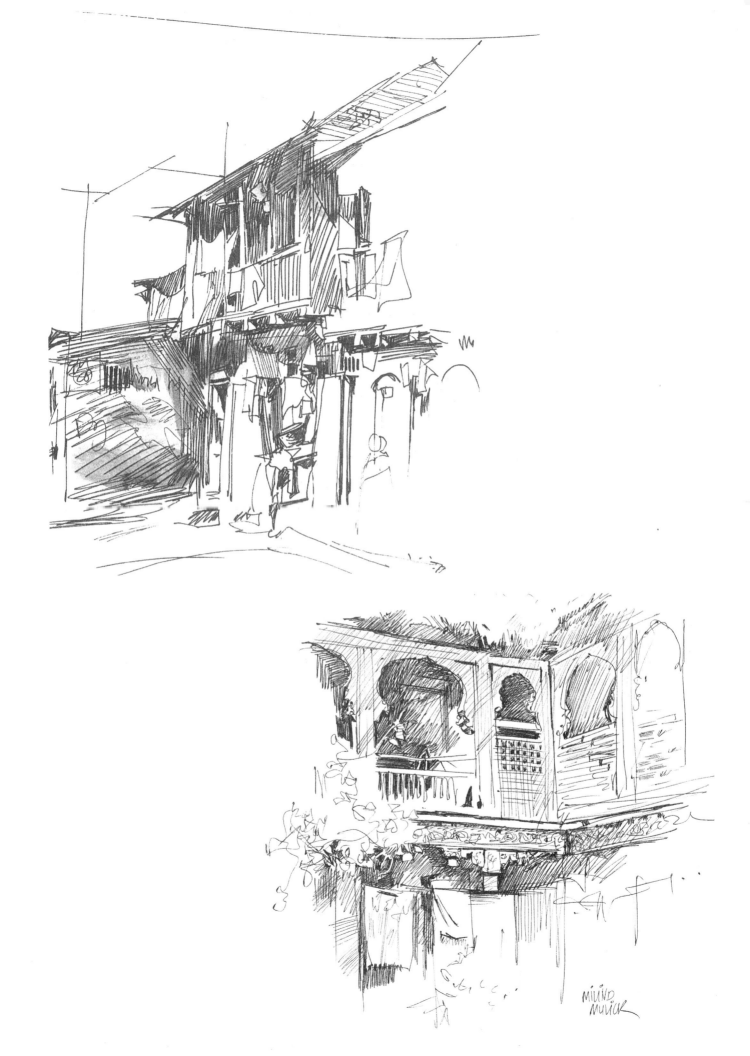

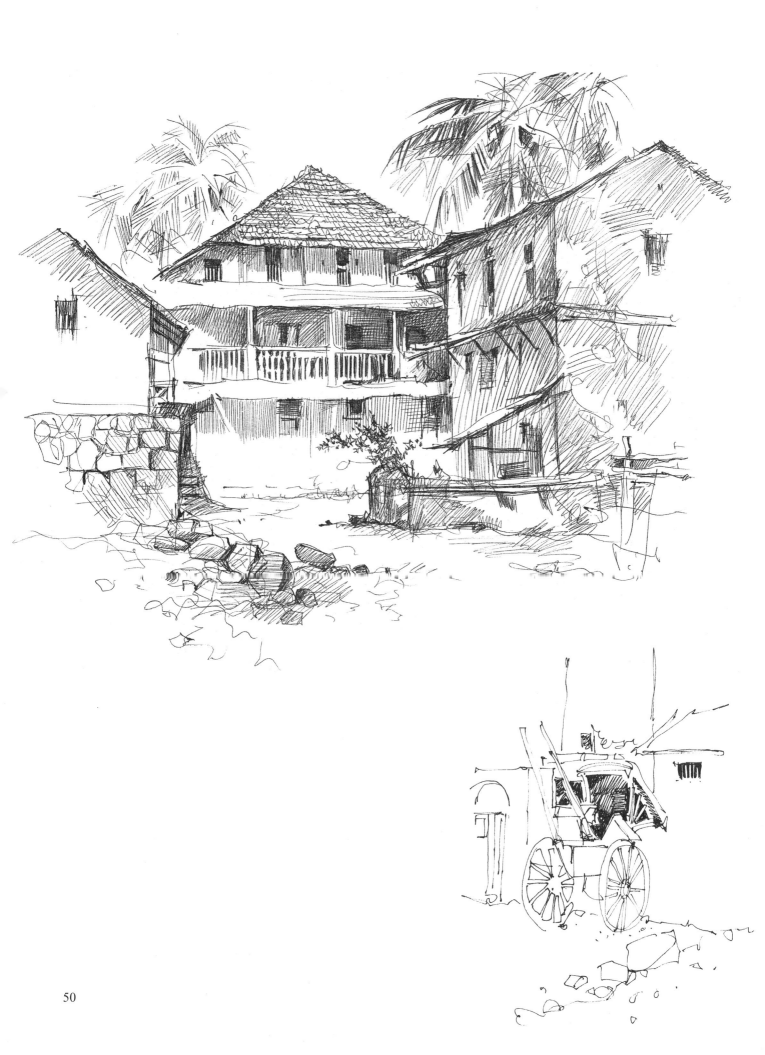

For a beginner it is more convenient to do an outline of
the painting before doing a sketch. After the technique
of space division is mastered, one can tackle any
subject, however complicated it may be. Later, one
need not do the outline. What has to be painted can
easily be perceived and one sets to work.

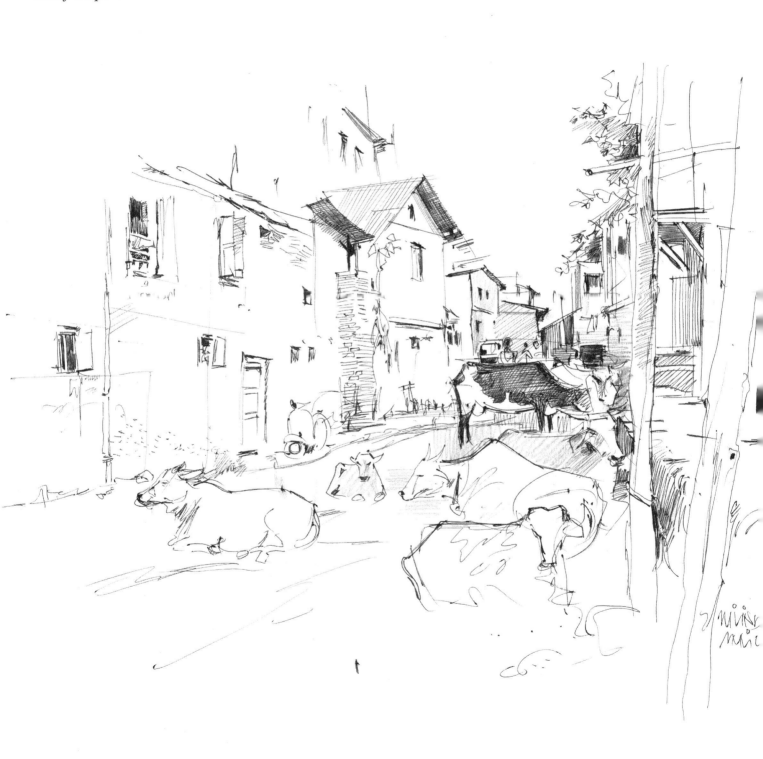

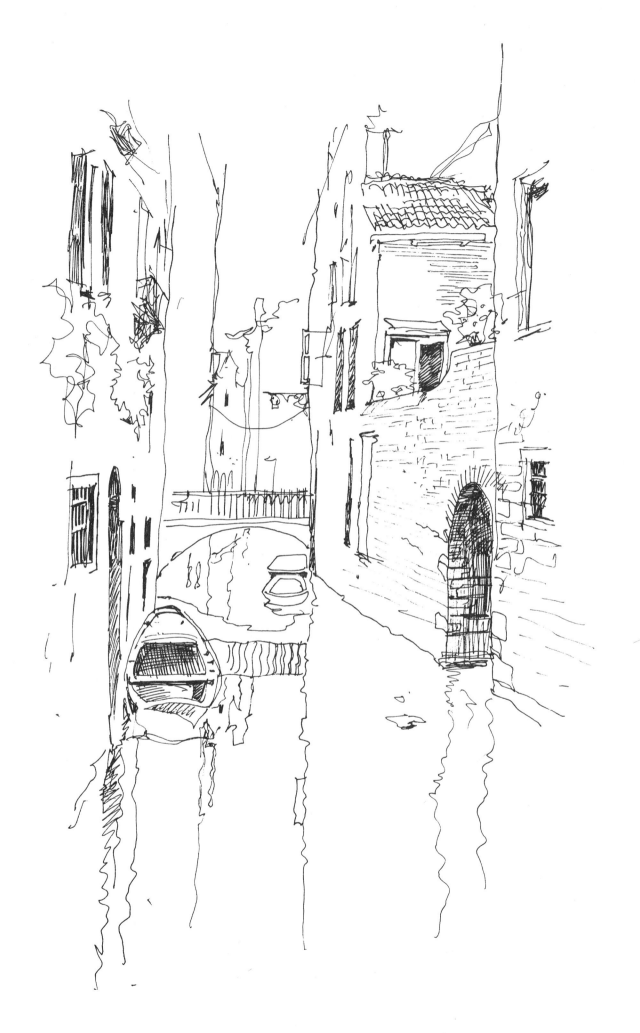

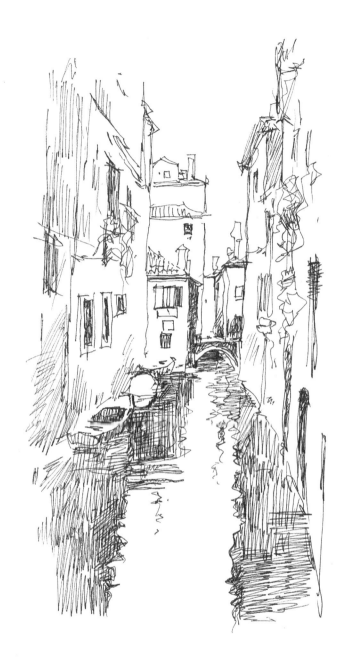

When we do a sketch for practice, our attention is first drawn to the form before us, and its proportionality. But as we complete the sketch, we realise the beauty spots in the scene. The beauty in the interplay of light and shadow, and their tonal relation; shapes in the shadow... begins to get revealed. Shades of colour also begin to be visible.

When a scene becomes a painting, the beauty of the painting is not the visual description of the subject but the poetry of interrelationship of lines, forms, colours and tones.

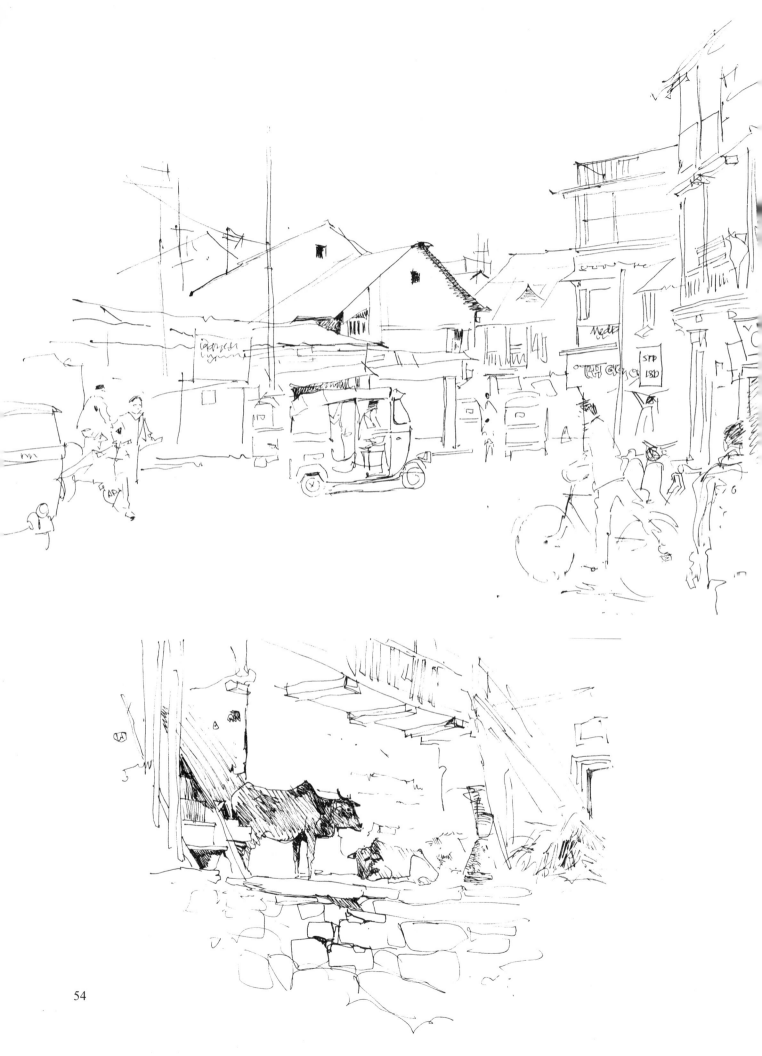

54

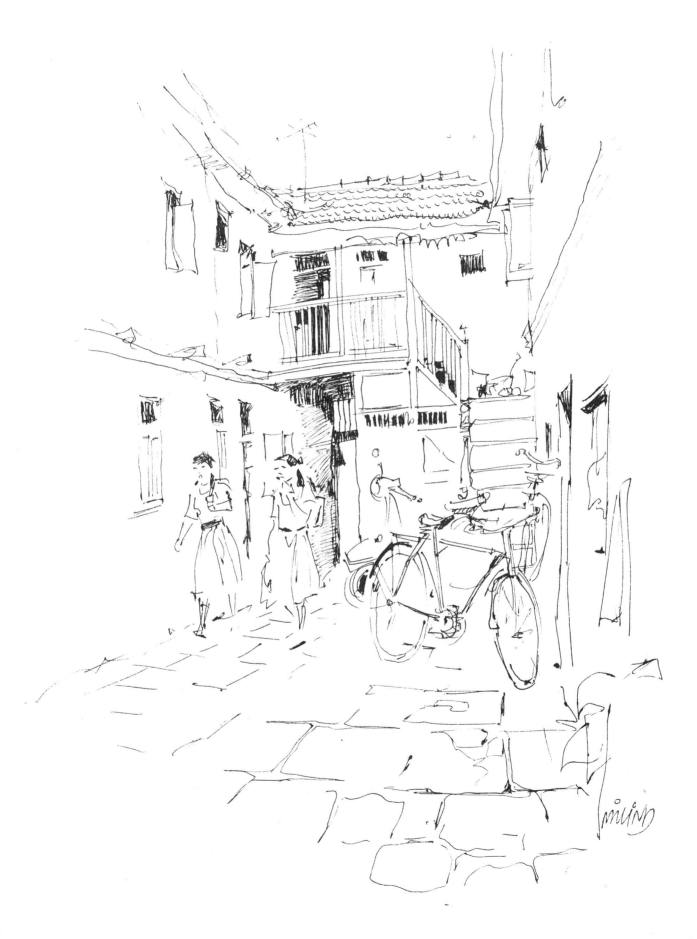

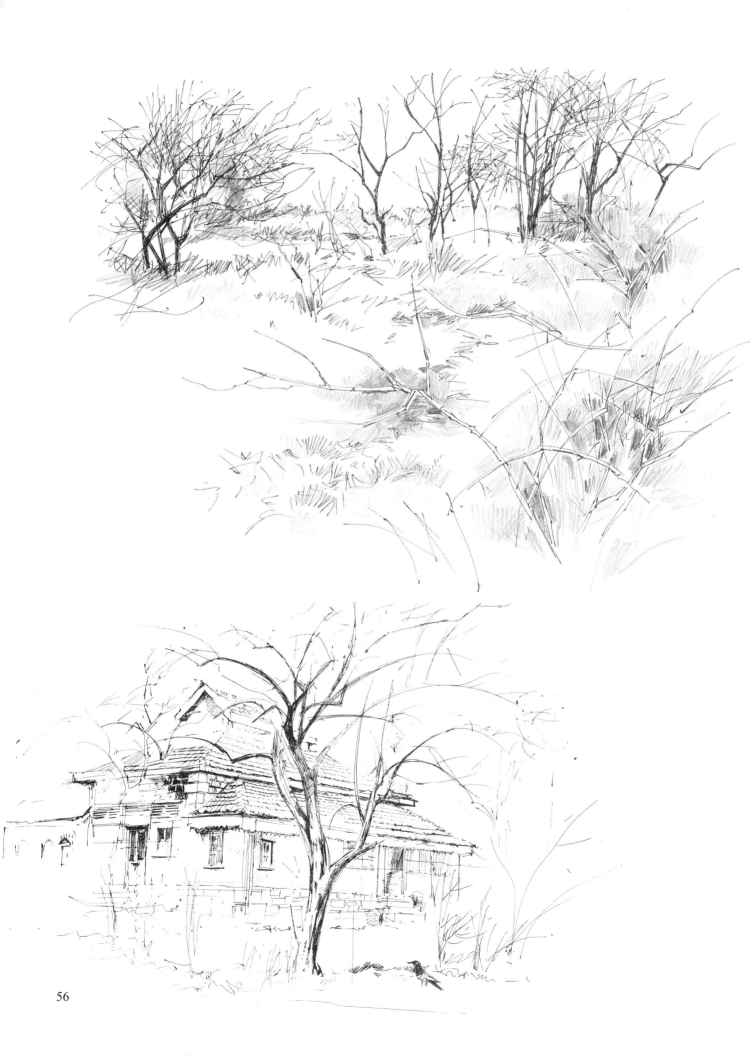

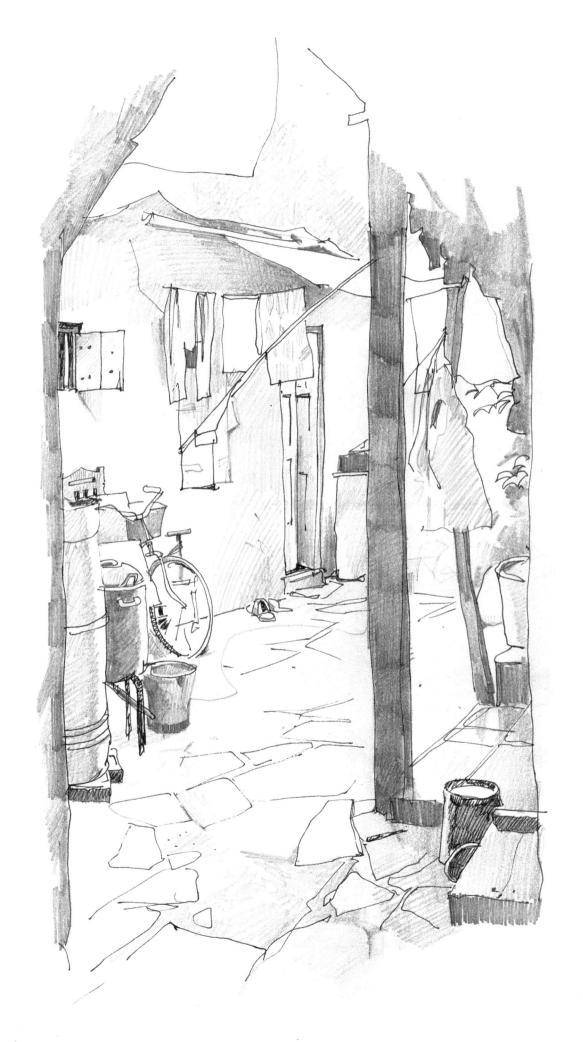

Study

A preparatory sketch for a painting is known as a study. The purpose of a study is exploring various options as well as finalising a few points with reference to the painting. A study in a way is a hypothetical painting.

Thumbnail Study

Sketches can be made in small frames to finalise composition of a painting, that is, deciding on space division and design. The simplification expected in a painting begins with the small size.

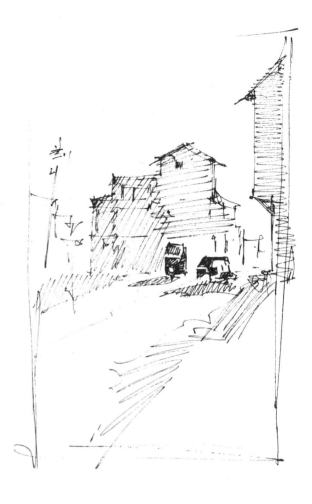

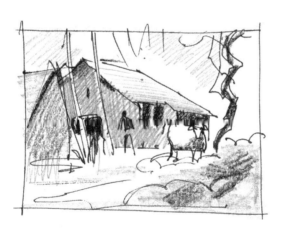

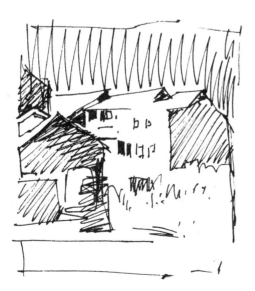

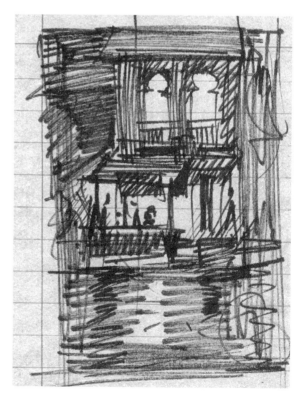

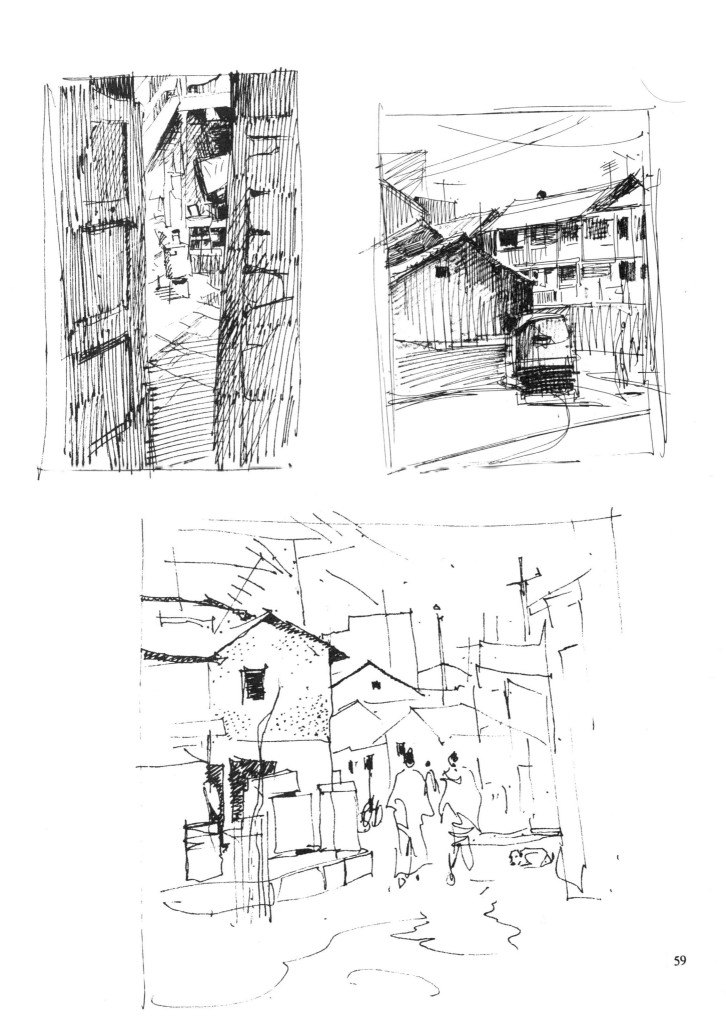

Tonal Study

Though a sketch or a drawing is made up of lines, a painting is a combination of forms, tones and colours. Lines do not exist in reality. In reality the lines of the edges of components change tones or colours without being visible. Lines are formed due to tonal change.

Relative lightness and darkness are expected in tonal study. Also assessed is where the dark and light patches occur and whether their proportion is suitable for the balance and unity of the painting. After shapes are completed in a painting, tonal study is more important than colours, details or techniques. In fact a painting stands out due to its tonal study.

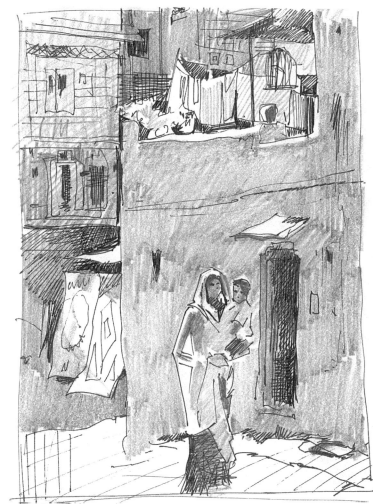

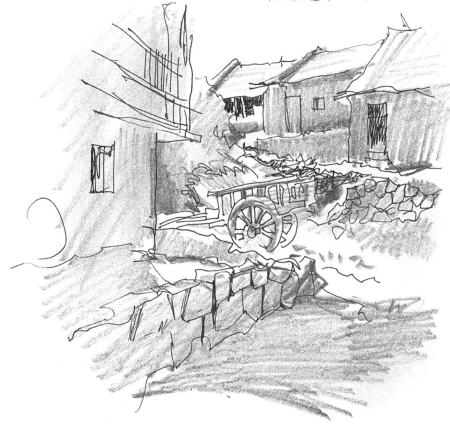

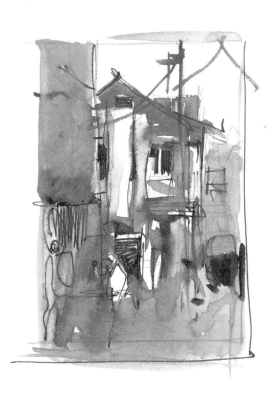

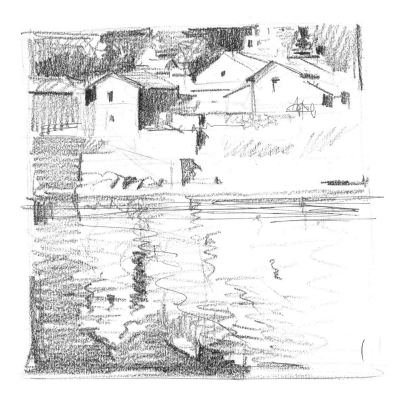

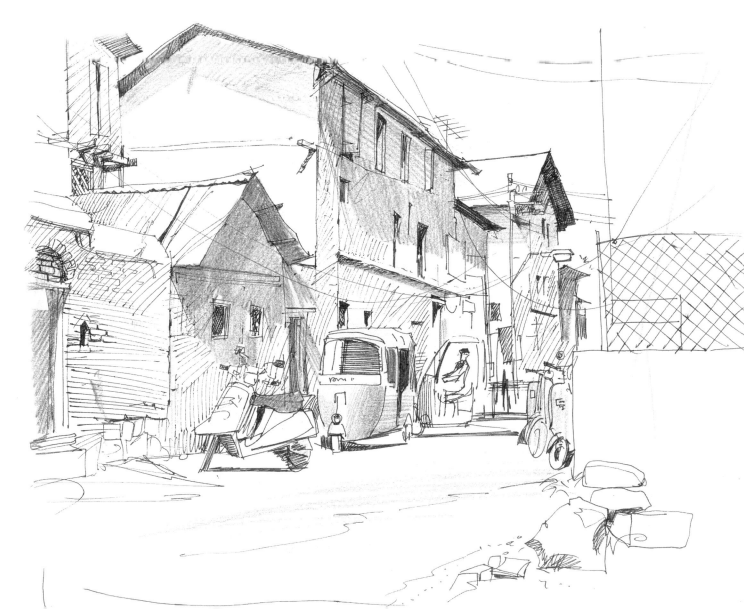

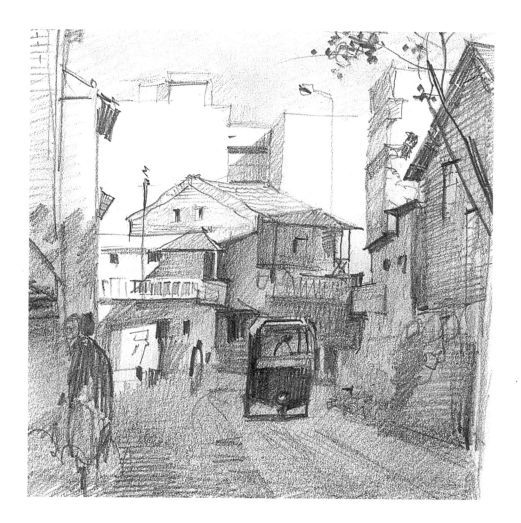

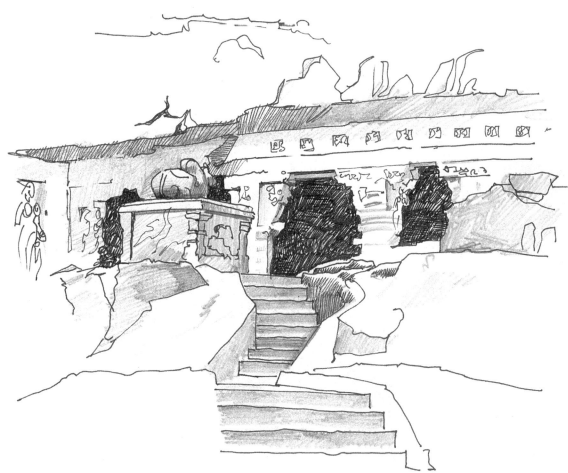

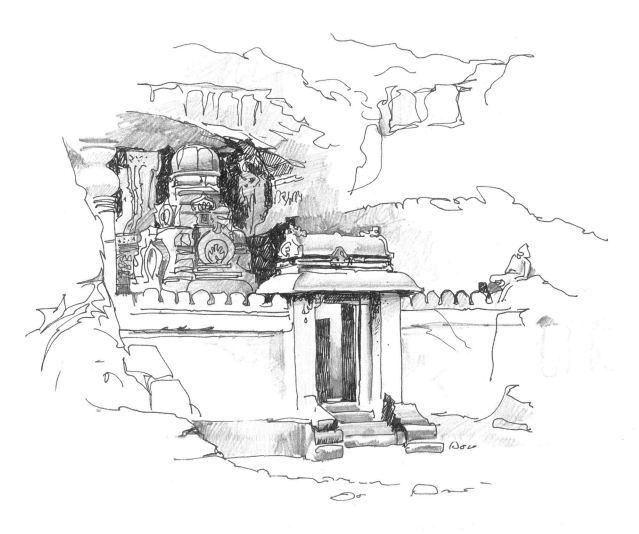

Tonal study not only finalises composition but also the thought process on how the colouring method should begin. Points such as whether it should be light to dark, dark to light or middle tone first; should it be flow of blending or broken colours, all get to be discussed at this stage.

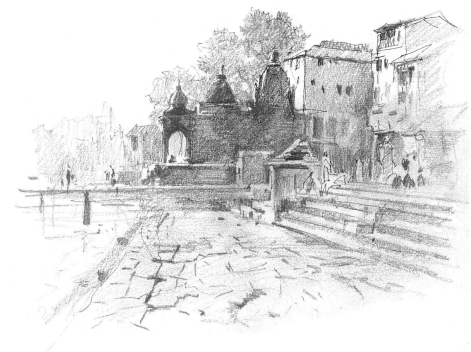

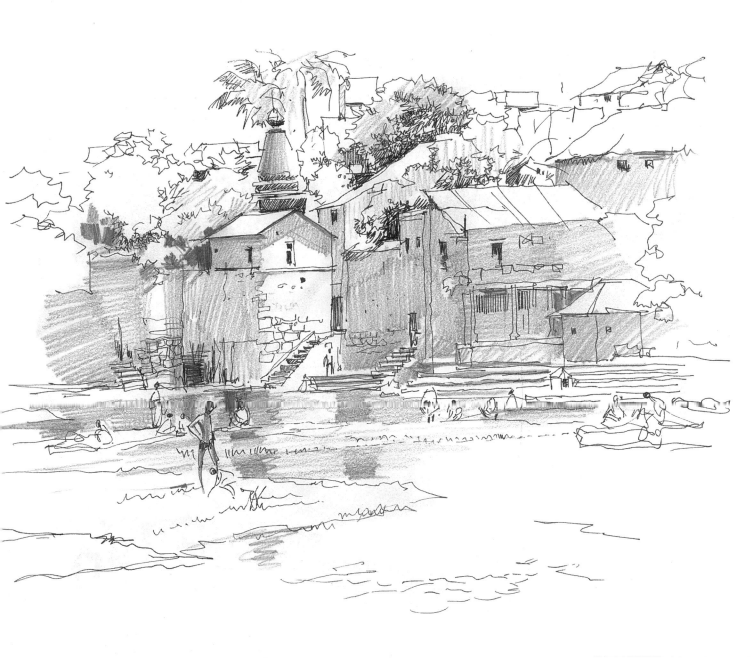

The purpose of a painter is not to show
houses, trees etc. He has to present the
play of light and shadow as well as
shapes meaningfully. He has to thus
know thoroughly the concepts of light,
shadow, tonal contrast, and tone of the
reflected light.

Colour Study

In the strict sense of the term, colour study is also a tonal study. But here at the same time, colour combination or experiments related to a different colour combination, high key or low key, that is, whether the colours in the painting should be light pastels or bright saturated etc. in the painting are also assessed.

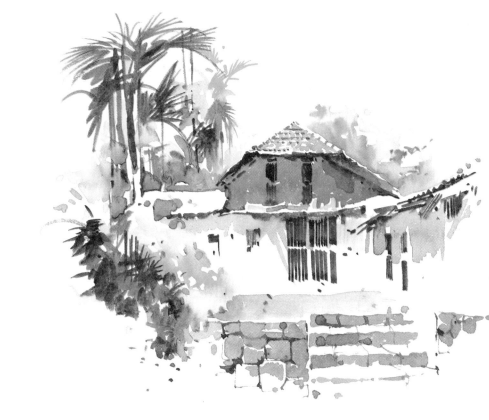

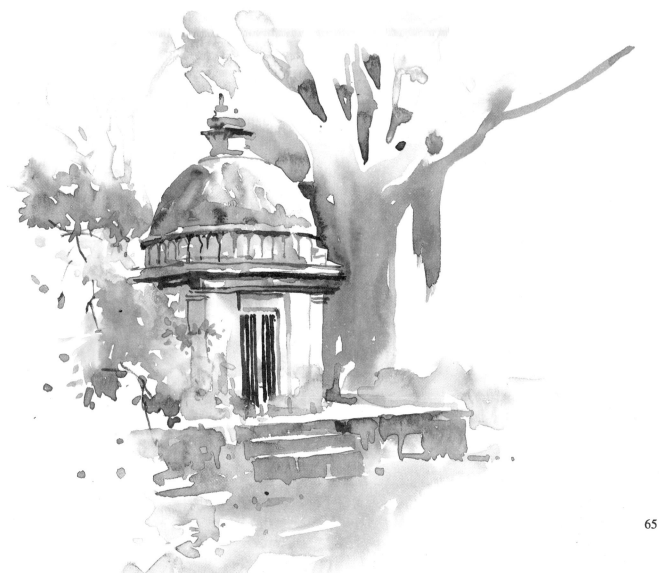

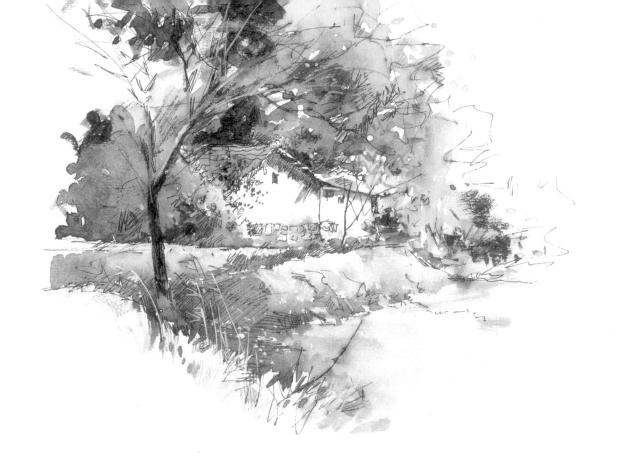

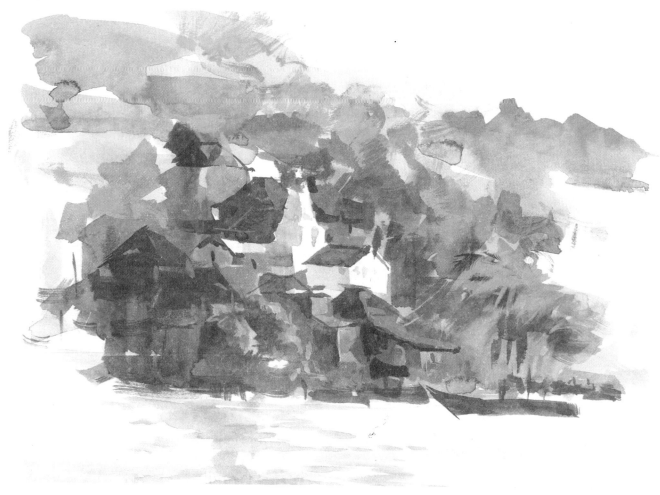

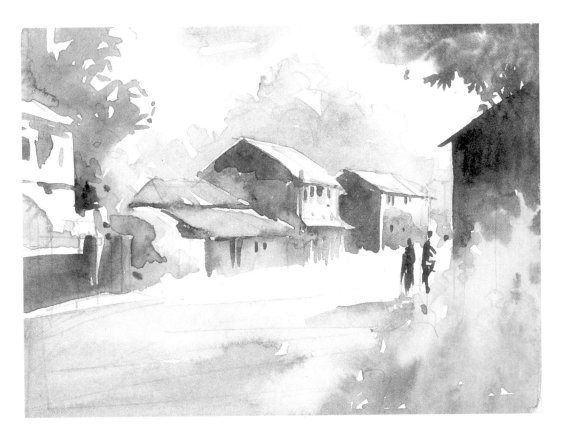

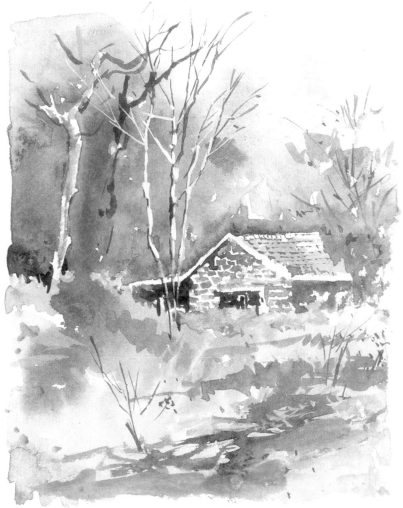

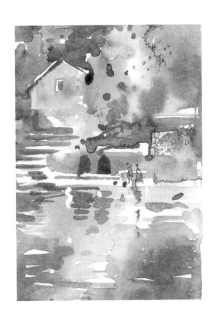

I started work on this painting with washes of watercolours. I had not given much thought then to shapes. Trees and buildings appeared as a result of strokes of dark tones. After completing brushwork, I used the pen to suggest stone paving, bushes... and completed the painting. I have used this method not only restricting it to sketches but also for actual paintings.

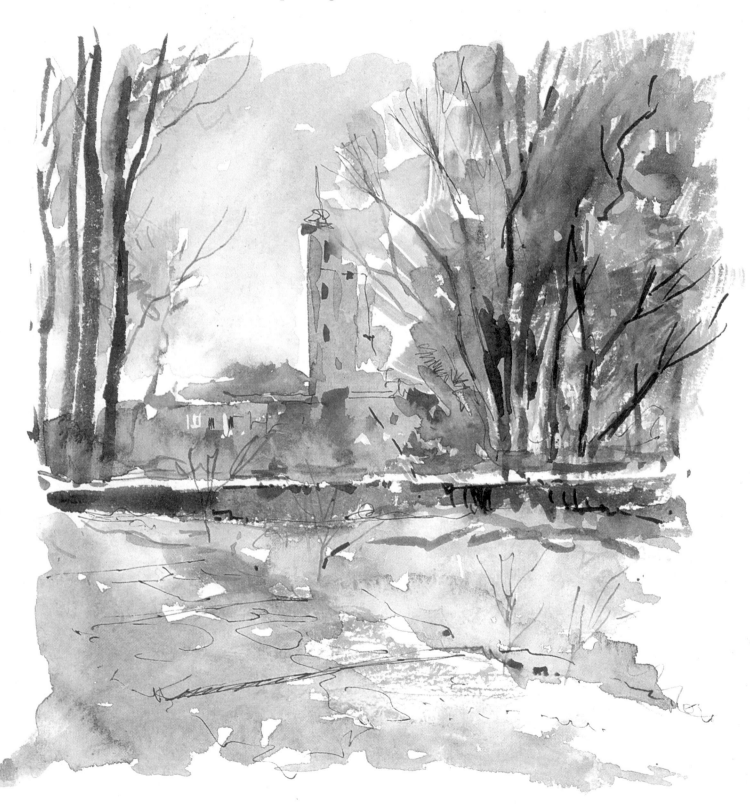

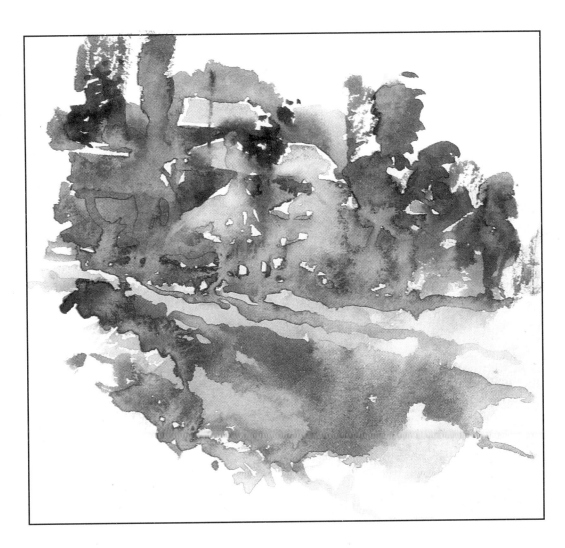

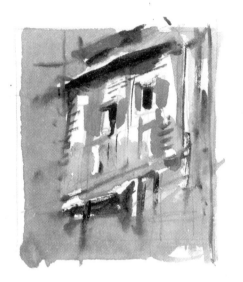

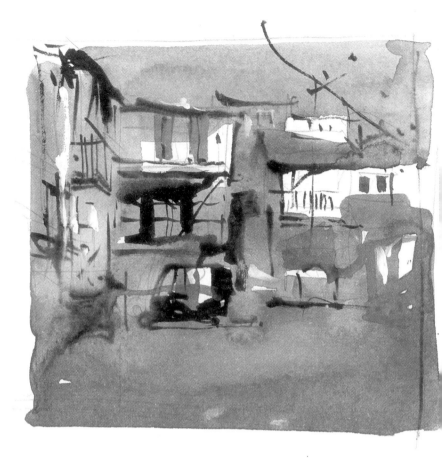

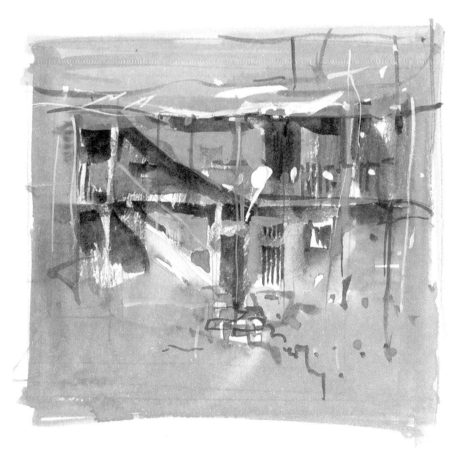

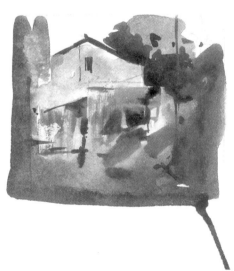

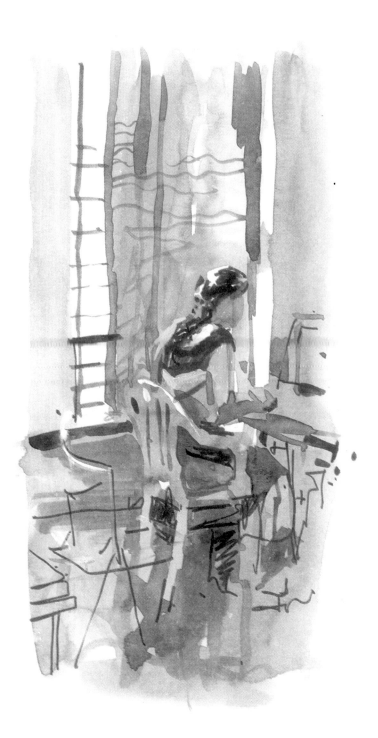
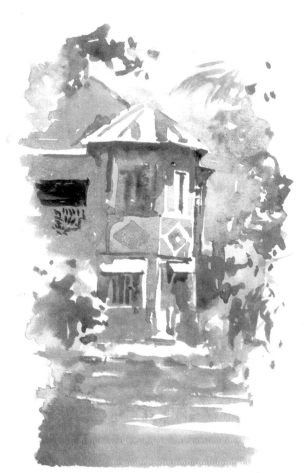
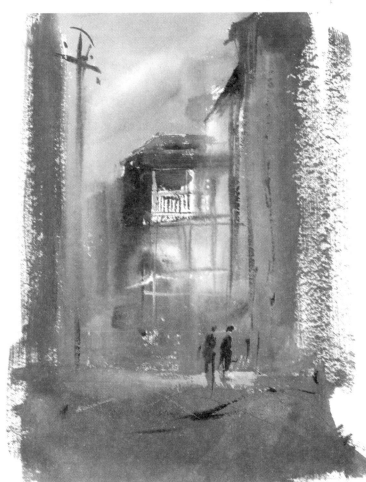

At times a sketch done for a study gradually becomes complete and meaningful. It not only includes the beauty spots of a sketch but also presents itself as a painting in itself. One does not feel like doing a bigger painting from the sketch.

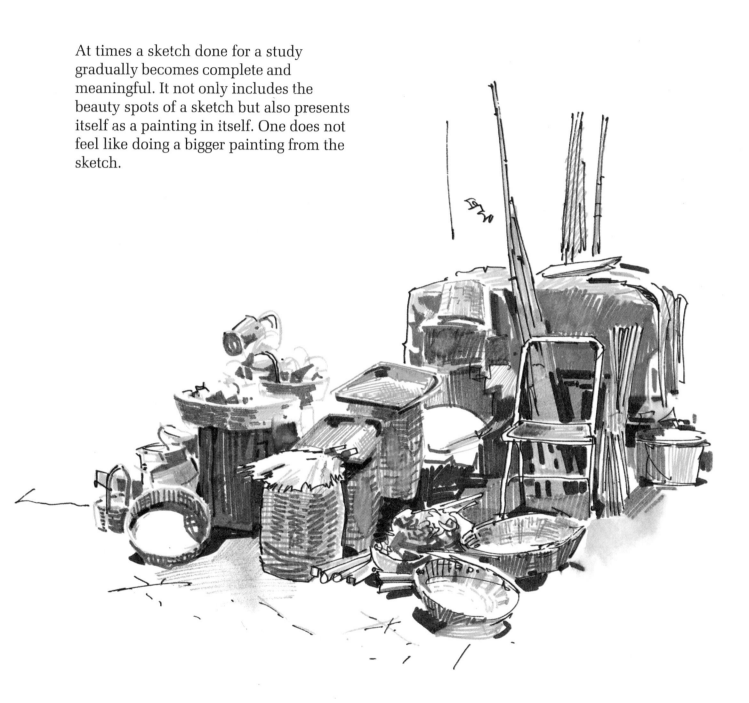

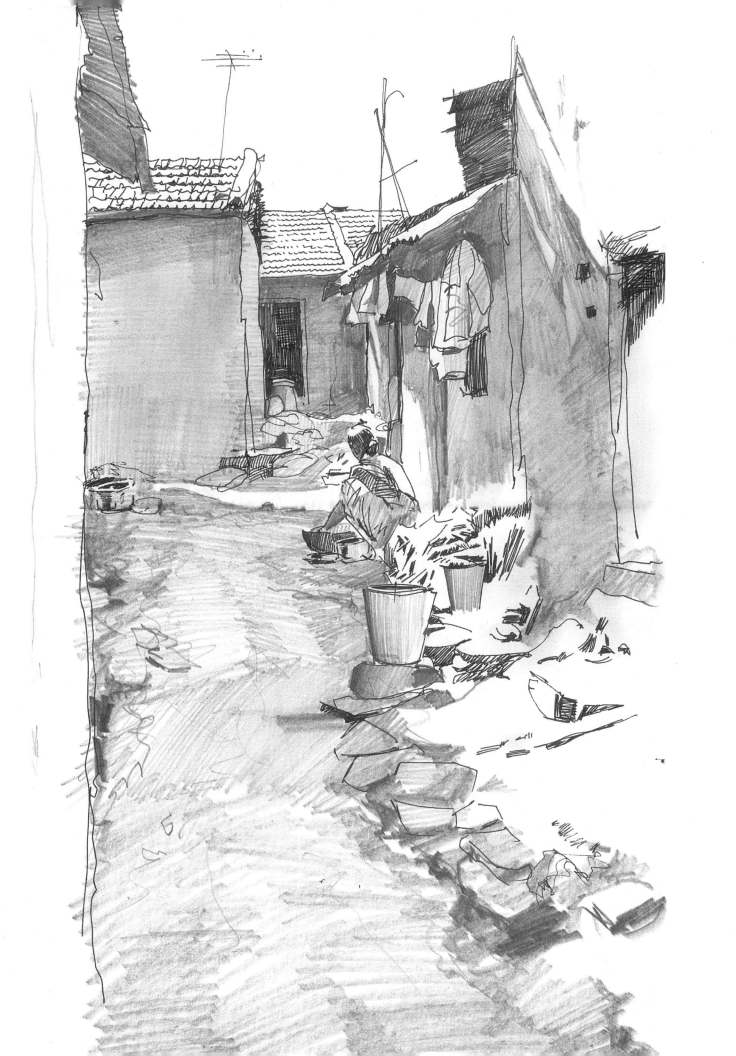

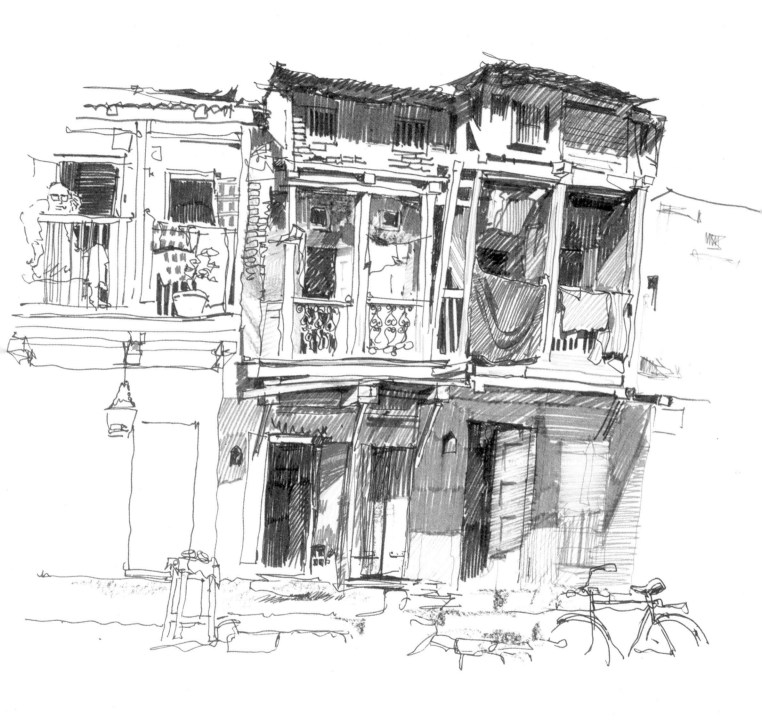

Wadas (old structures) in narrow lanes have always attracted me.

These houses have never experienced prosperity. Thus they are deprived of heritage protection.

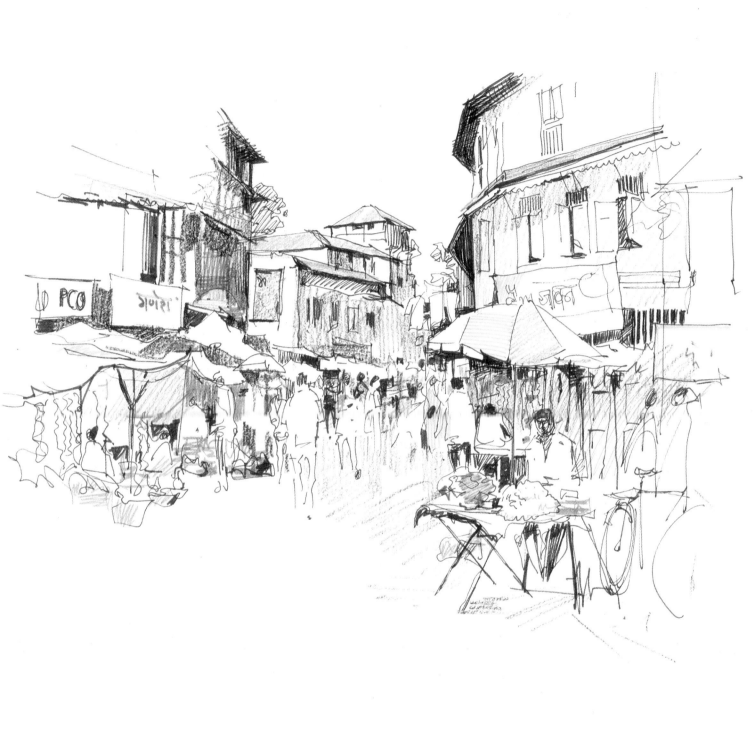

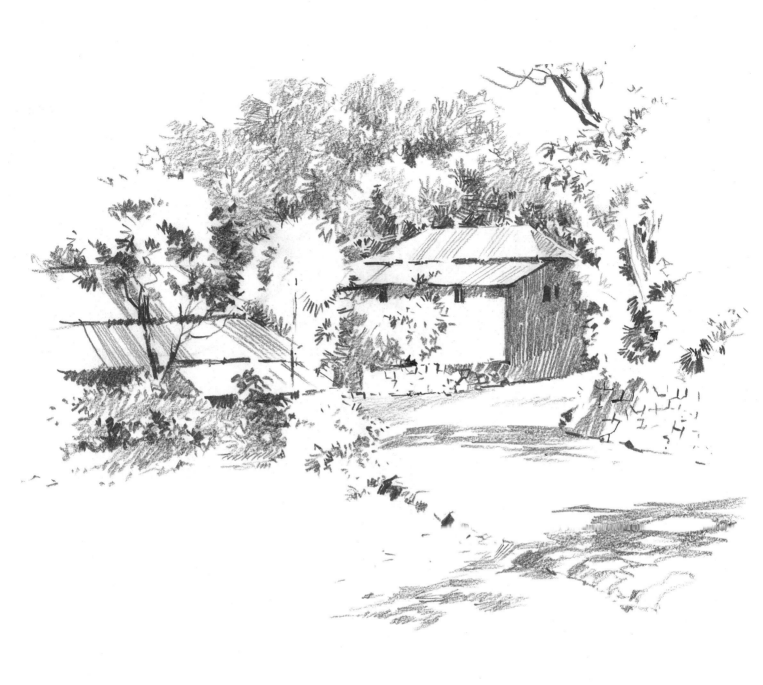

The houses and canals in Venice have allured a number of people. Narrow lanes dotted with traditional houses are seen almost everywhere in the world. But one gets to see their pleasant reflection in water only here in Venice.

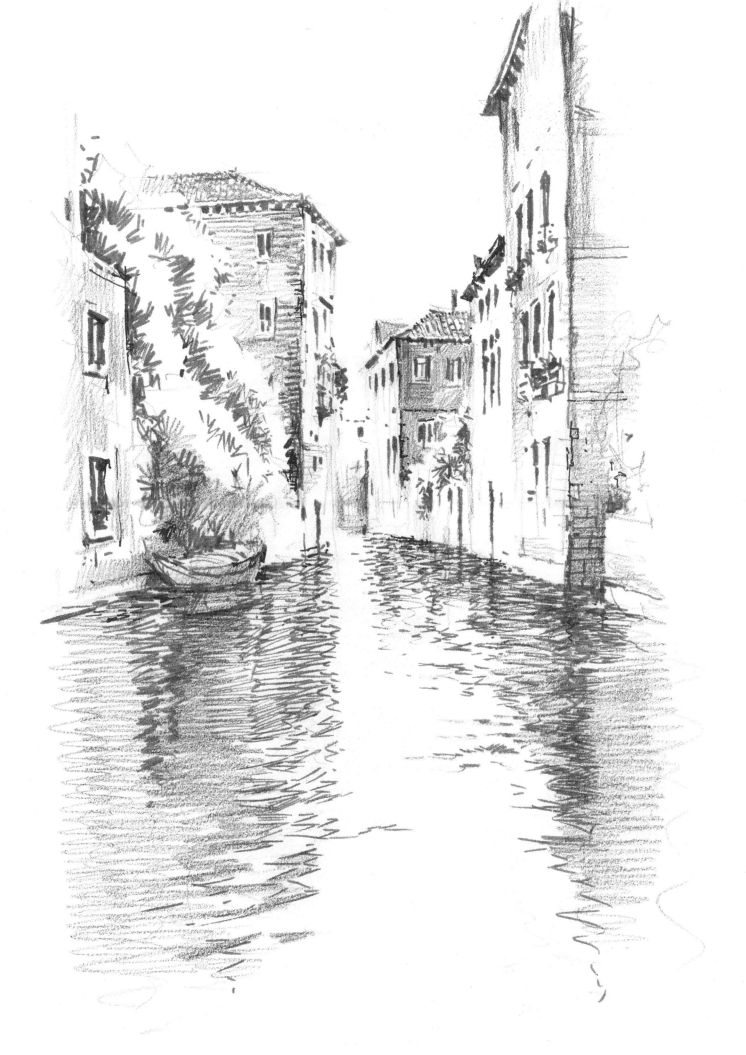

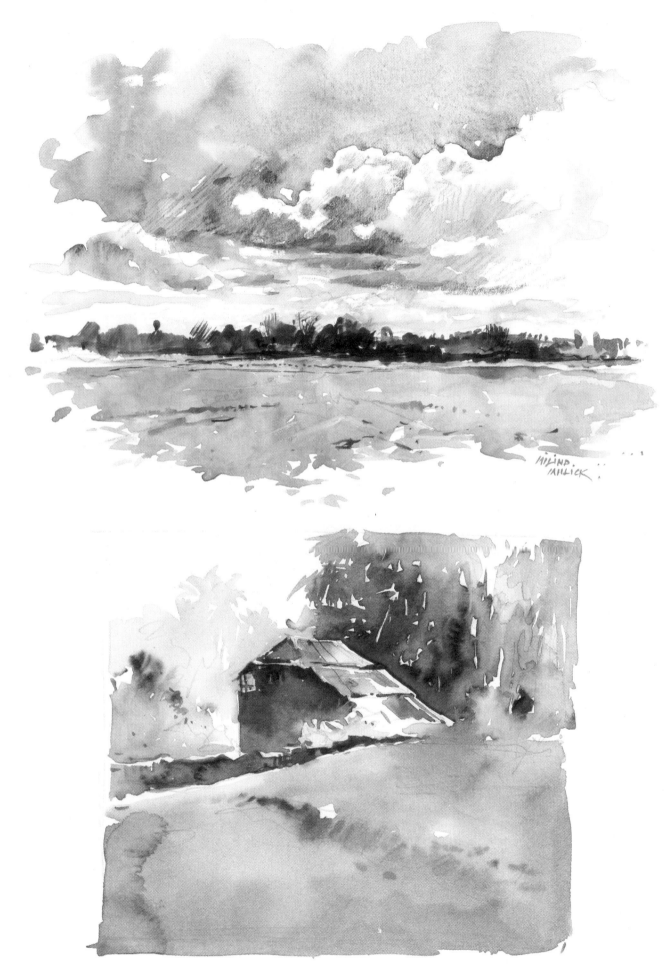

78

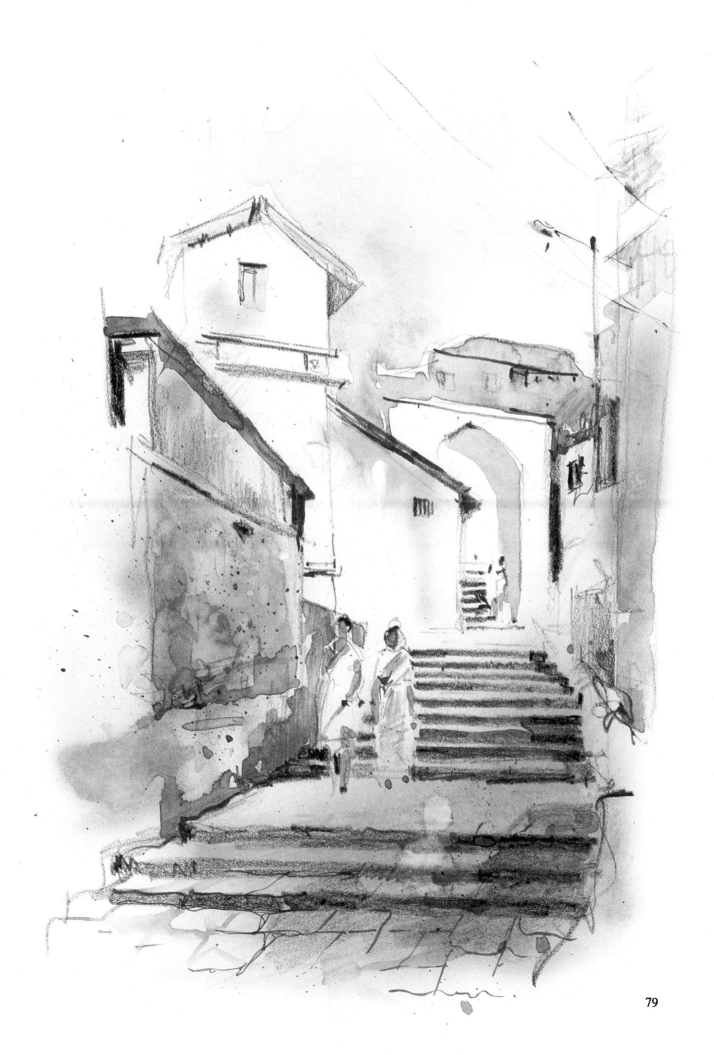

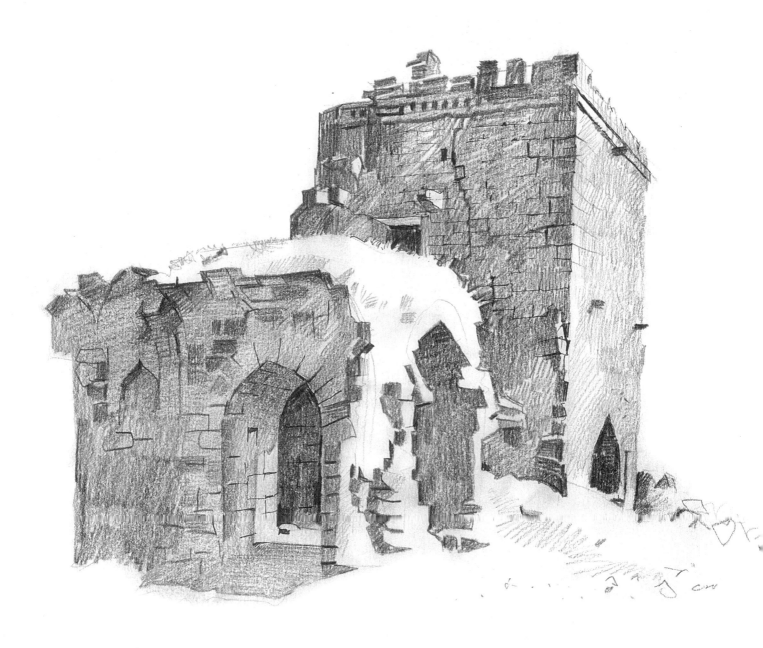

I do not know why I am
drawn to such relics of forts
and *havelis* (big buildings). Is
it the result of beauty of a
stone structure, the grass
grown over it which gives a
sense of being one with
nature, mystification or my
fondness about the past?

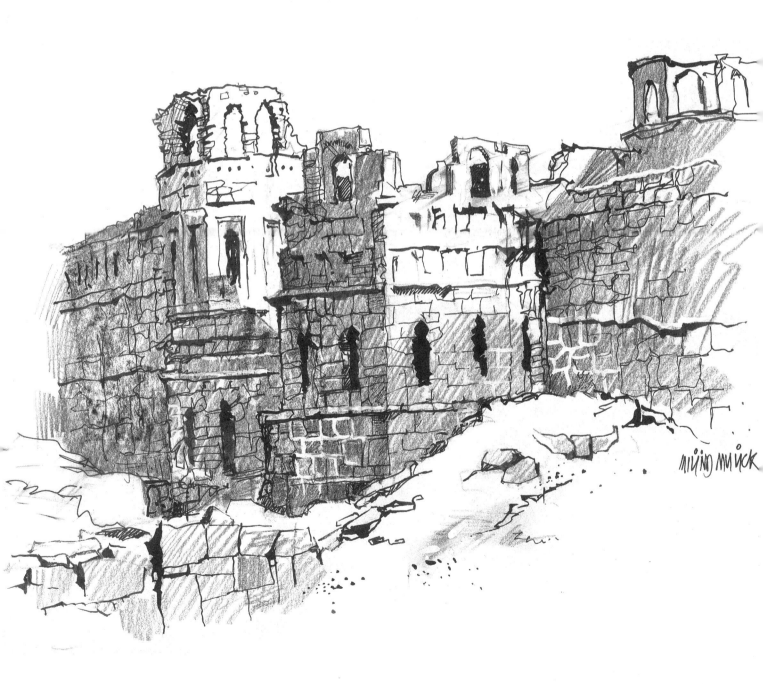

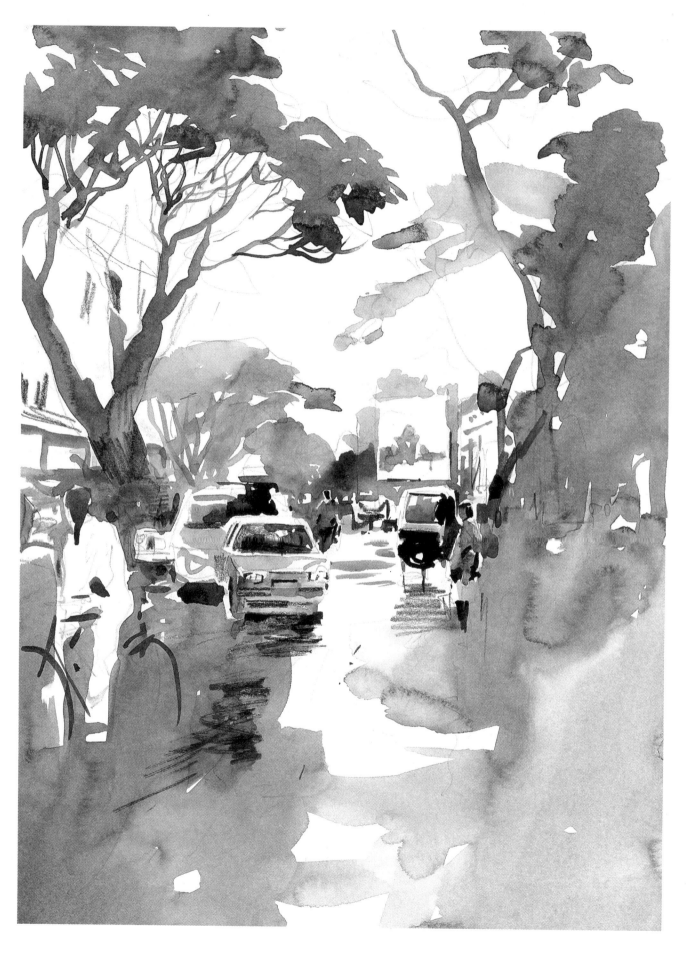

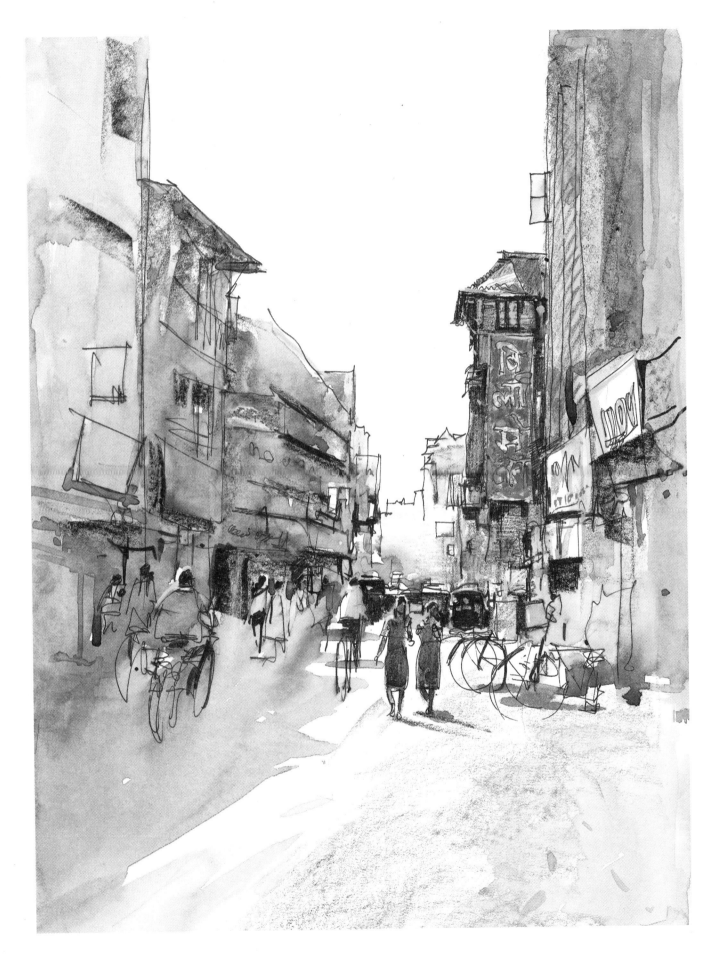

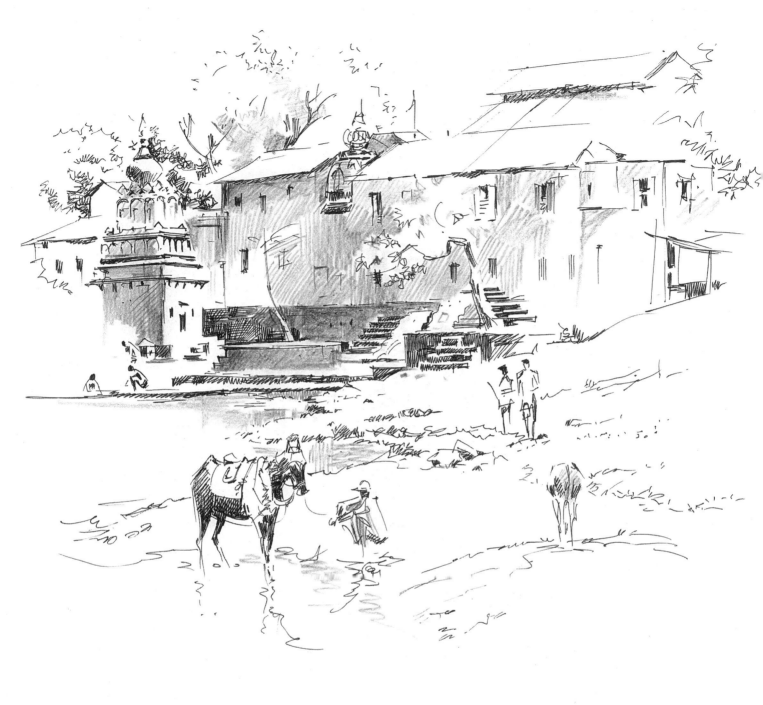

It is not necessary to depict all details. At times this part can be suggested elsewhere.

In the picture above, water has not been shown. But the blank space has been surrounded by such details that one feels the presence of water.

In both these sketches, small strokes have been used. The use of a line is almost avoided. This method is closer to painting.

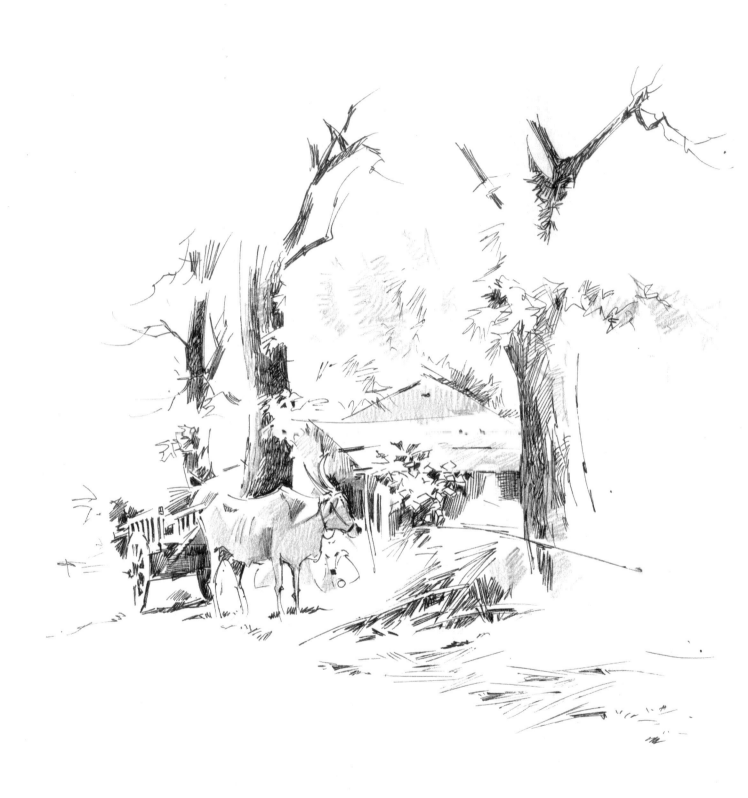

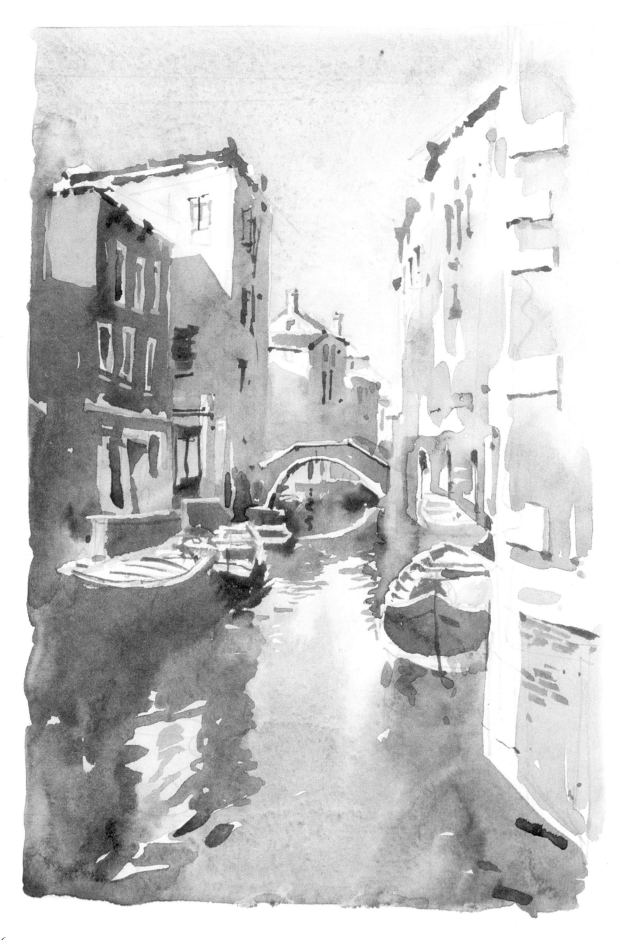

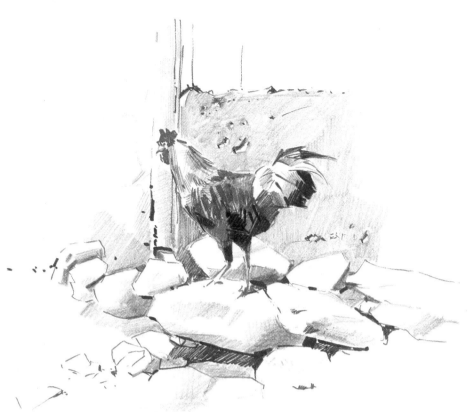

One need not always
explore scenic places for
painting. A simple still life
done for practice on the
dining table, such as this,
may lead to develop it into
a painting (below).

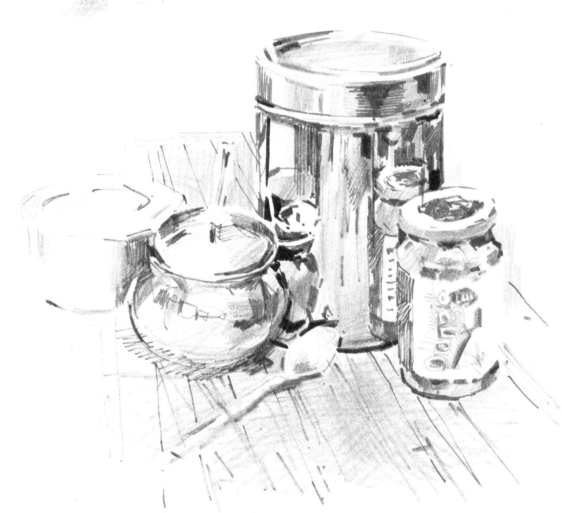

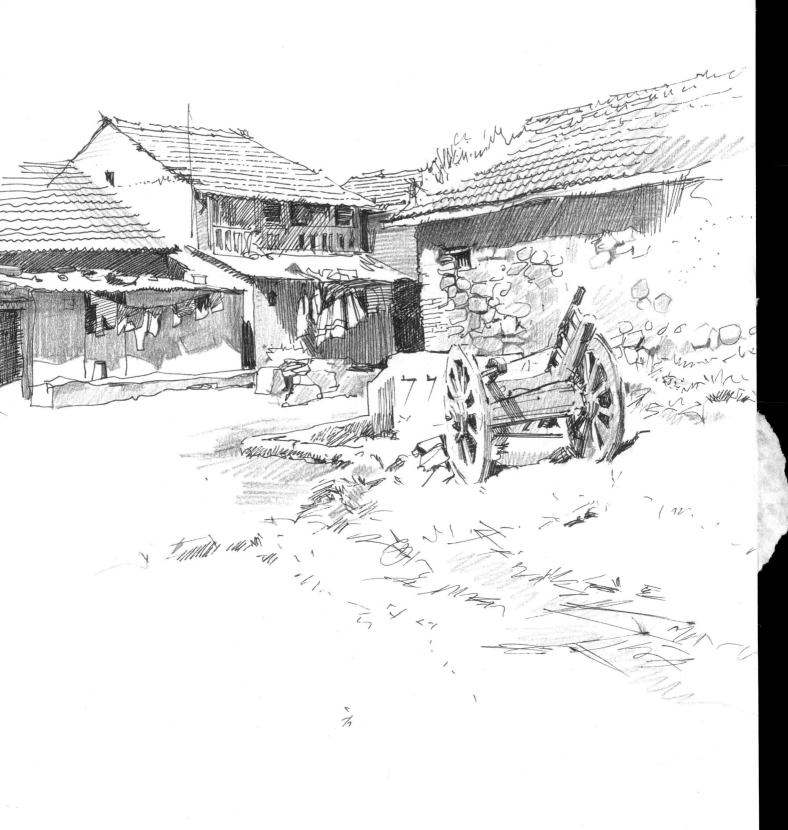